# IMAGES
## *of America*

# PINE RIDGE
# RESERVATION

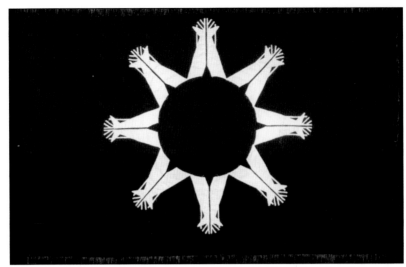

**OGLALA LAKOTA TRIBAL FLAG AND HISTORY.** The Oglala flag has eight white tipis in a circle. In the history of the Oglala Lakota, various bands would group together in encampment, and this is the basis for designing eight tipis in a circle. They represent the eight districts of the Pine Ridge Indian Reservation. Each tipi in the design represents one of the following political subdivisions of the reservation: Wakpamni District, Porcupine District, Wounded Knee District, Medicine Root District, Pass Creek District, Eagle Nest District, White Clay District, and LaCreek District. As the reservation grew, a ninth district was created for Pine Ridge District.

**FIELD OF RED:** *In the history books of the white man, the Indian is often referred to as "redman" and with this thought in mind and with the knowledge that much red blood of our forefathers had been shed in the struggle to preserve the homelands of the Oglala Sioux Tribe, the red field now represents the geometric outline of the Pine Ridge Indian Reservation, home of the Oglala Sioux Tribe.*

**BLUE BORDER:** *The blue border was basically designed to represent the blue sky as seen in all four cardinal directions during the worship of the Great Spirit and the elements, and the sky as the land of now departed relatives "the happy hunting grounds." In modern times the blue represents the loyalty of the Oglala Sioux Tribe to the United States of America, especially during times of international conflict.*

*The original tribal flag was given tentative approval by members of the Tribal Council in time to be displayed for the first time during the Sun Dance Celebration of 1961. By legal action of the Tribal Council on the 9th day of March, 1962, this flag was adopted as the official flag of the Oglala Sioux Tribe. The flag was designed by the late Enos Poor Bear Sr. and the late Lloyd Eagle Bull Sr. (Flag courtesy of the Oglala Sioux Tribe.)*

**OGLALA HISTORY:** *In November 1841, the leader Bull Bear was killed in a feud with the leader Smoke. Bull Bear's group was known as the Bear People and Smoke's group was known as the Bad Face or Smoke People. This event caused the Oglalas to split into a northern and southern division with the people of Smoke being in the north and the Bear People moving to the south. The Oglala Bad Face, Red Cloud came into prominence as a leader following this division and he would later be the main "Chief" recognized by the United States in its dealings with the Lakota. The general location of the northern group during this time period included present South Dakota, Wyoming, and northern Nebraska. The southern Bear People moved south to the area of present southern Nebraska and northern Kansas. The Republican River area was a favorite camping spot near the Nebraska/Kansas state line.*

*Crossing central Nebraska is the Platte River and this area would become congested with non-Indians moving west on the Oregon Trail, Mormon Trail, and the soon to be established Bozeman Trail. Their resting destination was Fort Laramie. As a result, the Oglala and Sicangu Lakota became the most studied of the seven Lakota groups. When northern Lakota bands visited these southern Lakota they were sometimes mistaken as Oglala. Many museums have misidentified photos, listing those pictured as Oglala when they were sometimes other Lakota bands.*

IMAGES
*of America*

# PINE RIDGE
# RESERVATION

Donovin Arleigh Sprague

ARCADIA

Published by Arcadia Publishing
Charleston SC, Chicago IL, Portsmouth NH, San Francisco CA

Printed in the United States of America

Library of Congress Catalog Card Number: 2004113140

For all general information contact Arcadia Publishing at:
Telephone 843-853-2070
Fax 843-853-0044
E-mail sales@arcadiapublishing.com
For customer service and orders:
Toll-Free 1-888-313-2665

Visit us on the Internet at www.arcadiapublishing.com

*Dedicated with love to…*

*Marcie Sprague Pudwill*
*Brandon Sprague*
*Rylan Sprague*

# CONTENTS

Acknowledgments                                                          6

Introduction                                                            7

1.    Oyate (People/Nation)                                             9

2.    Fetterman Okicize (Fetterman Fight)                              29
      Canpagmiy Anpi Okicize (Wagon Box Fight)
      Maga Wakpa Okicize (Hayfield Fight)
      Peji Sla Okicize (Battle of Greasy Grass/Battle of the Little Bighorn)

3.    Mahpiya Luta Owakpamni (Red Cloud Agency)                        53

4.    Wanagi Wacipi Na Cank'pe Opi                                     67
      (Ghost Dance and Wounded Knee)

5.    Wazi Blo Owakpamni (Pine Ridge Agency)                          71

6.    Owayawa El' Tipi (Boarding Schools)                            109
      Wounspe Teca (New Education)

7.    Wazi Blo Owakpamni (Pine Ridge Reservation) 1950–2005          117

Index                                                                126

Bibliography                                                         128

# ACKNOWLEDGMENTS

Thank you to my friends, past and present, who provided conversation, kindness, or assistance to me:

Loretta Afraid Of Bear, Denver American Horse, Bill and Geraldine Anderson, Paula Anderson family, Dennis Banks, Lou Ann Barton, Mildred Benway, Wilbur Between Lodges, CeCe Big Crow, Chick Big Crow, Gene Black Crow, Madonna Blue Horse-Beard, Emil and Alice Blue Legs, Doyle Bramhall, John Brewer, Eddie Brigati, Marcel Bull Bear, Harry Burk, Catches family, Chipps family, Jay Citron, Eddy Clearwater, Scott Clifford, Crazy Horse Memorial, Crazy Horse Tiwahe, Fedelia Cross, James Cummings, Charlie Daniels Band, Dull Knife family, Fabulous Thunderbirds, Marie Fox Belly, Marty Frog, Tim Giago, Billy Gibbons, Samantha Gleisten, Geri Goes In Center-Witt, Larry and Cynthia Gonzalez, Mario and Dorothy Gonzalez, Grey Eagle Society, Renee Greenman, Bill Groethe, Merle Haggard, Ted Harvey, Francis He Crow, Michael He Crow, Claire Heldman, Darlene Helper, Pete Helper, Michael Her Many Horses, Rex Herman, Bryant High Horse, Duane Hollow Horn Bear, Bonnie Holy Rock, Johnson Holy Rock, Lenora Hudson, Wiyaka Hudson, Hump Tiwahe, Ed Iron Cloud, Waylon Jennings and Jessi, B.B. King, *Lakota Nation Journal*, Jonny Lang, Marie Yellow Bird Lange, Ernie and Sonja LaPointe, Bob Lee, Pat and Faith Lee, Darv and Sis Lewis, David and Joanie Lindley, Leonard Little Finger, Little Sky family, Barbara Logan, Karen Lonehill, Lone Horn Tiwahe, Clement Long, Daniel Long Soldier, Mabel Long Soldier, Erma Maldonado, Janeen Melmer, Bart Merdanian, Berneita Miller and family, Billy and Pat Mills, Deloris Mills, Joel Minor, Don Montileaux, Musée de l'Homme, Mandi Mutchler, Willie Nelson, Oglala Lakota College Archives, Oglala Sioux Tribe, Bob and Nell Pearson, James Pipe On Head, Pooley family, Marilyn Pourier, Scott Pourier, Todd and Dylan Pudwill, Martin Red Bear, Buddy Red Bow, Stephen and Maize Red Bow, Red Cloud Indian School and Heritage Center, Lula Red Cloud, Lily Mae Red Eagle, Dollie Red Elk, Tina Red Horse, Sharon Richards, Jimmy Rogers, Junior Rousseau, Alvina Runs After, Grover Scott, Lila Serfling, Seven Council Fires, Mark Shillingstad, Thomas, Darlene, and Vanessa Shortbull, Brother Simon S.J., Nancy Sinatra, "Skip" Spotted War Bonnet, Darrel and Velda Sprague, Deb Sprague, Ivan Starr, Stephen Starr, Ken Stewart at S.D. State Archives, Chub Thunder Hawk, Ben Trent, Mike Trent family, Tanya Tucker, Andrea Two Bulls, Eddie Two Bulls Sr., Lorrie Two Bulls, Matt and Nellie Two Bulls, Reverend Robert Two Bulls, Tom Two Bulls, Rick Two Dogs, Buzzi Two Lance, Delphine Two Two, Newton Two Two Jr., Vance family, Jimmie Vaughan, Stevie Ray Vaughan, Wakan Tanka, Elizabeth Whipple, David White Bull, Francis White Lance, Tom Wilson, Alvera Wise, Wounded Knee Riders, Wounded Knee Survivors Assn., Milo Yellow Hair, Carmen Yellow Horse, Leonard Youngbear, Ray Youngbear, Ed Young Man Afraid Of His Horses, Korczak and Ruth Ziolkowski family, ZZ Top, and to my high school and college classmates.

# INTRODUCTION

The name Sioux is part of the Ojibwe/Ojibway/Chippewa/Anishinabe word *Nadoweisiw-eg* which was given to the Sioux when they lived near the Ojibwe, and later the French shortened the word to Sioux. The original word meant "little or lesser snakes/enemies." The Sioux are really three groups comprised of the Lakota, Dakota, and Nakota, each having slightly different language dialects. There are seven groups of Lakota and the Oglala are the largest. The Pine Ridge Indian Reservation was created for the Oglalas and they are the main subject of this book. The other six Lakota groups are the Sicangu located at Rosebud Indian Reservation and Lower Brule Indian Reservation, the Hunkpapa located at Standing Rock Indian Reservation, and the Minnicoujou, Itazipco, Siha Sapa, and Oohenumpa, all located at Cheyenne River Indian Reservation. Pine Ridge Reservation, home of the Oglalas is located in southern South Dakota. The Sicangu are located at both Rosebud Reservation just east of Pine Ridge Reservation in southern South Dakota and Lower Brule Reservation on the Missouri River in central South Dakota. The Hunkpapa are located at Standing Rock Reservation in north central South Dakota and extend into south central North Dakota. Some Siha Sapa and some Dakota/Nakota bands also reside at Standing Rock. The four bands of the Minnicoujou, Itazipco, Siha Sapa, and Oohenumpa are at Cheyenne River Reservation, which is located in north central South Dakota, just south of Standing Rock. Some of the Lakota also settled in the Wood Mountain Reserve area in Saskatchewan, Canada.

Pine Ridge Reservation was originally part of the Great Sioux Reservation which was created by the 1868 Treaty of Fort Laramie with the United States Government. The original boundaries included all of present western South Dakota from the east bank of the Missouri River to the Wyoming state line in the west. There is additional unceded land of the Sioux taken which went further into Wyoming to the Yellowstone River and south into Nebraska to the Platte River. All but the present existing boundaries of the five Lakota reservations were taken in violation of the 1868 Treaty of Fort Laramie or Acts of Congress. A main portion of the land taken includes the sacred Black Hills of the Sioux Nation (Lakota/Dakota/Nakota). In the 1800s, several treaties were entered into between the Sioux and the U.S. Government. With each new treaty the Sioux lost more land until finally, in 1889, the Great Sioux Reservation was reduced to five separate reservations. Before Pine Ridge Reservation was named, it evolved from the first location of the Red Cloud Agency during the years 1871-1873, just east of Fort Laramie in present southeastern Wyoming.

Fort Laramie had been established in 1834 as a private fur trading post. This became a trade center for the Lakotas and many of them, especially Oglala and Sicangu, began living near the area. The fort was first called Fort William and later took the name Fort Laramie after the Laramie River. At this time, America was expanding westward into Lakota territory. In 1841 the American Fur Company replaced this old fort with a walled fort named Fort John. The second Fort Laramie was completed in time for the first wagon trains of emigrants arriving in 1841 on their way west. In 1849, Fort John was sold by the American Fur Company for $4,000 and ended the fort's 15-year history as a private trading post. The U.S. Army began

construction of buildings here for the next 41 years and Fort Laramie grew to become the largest and most important post on the Northern Plains, serving as a supply center for emigrants going to Oregon, California, and traveling the Mormon trails. Fort Laramie was the site of the famous 1851 and 1868 Treaties of Fort Laramie with the Lakota and other tribes involved.

The Pine Ridge Reservation is the second largest Indian reservation in the United States and the southern boundary of the reservation is the Nebraska state line. The reservation includes over 11,000 square miles in seven counties: Shannon, Bennett, Custer, Fall River, and Jackson counties in South Dakota. Approximately 120,000 acres of the reservation are in the Badlands. The White River winds west from the Missouri River in central South Dakota out to Pine Ridge Reservation where it crosses the reservation and continues in a southwestern direction. White Clay Creek, Medicine Root Creek, and Bear in the Lodge Creek all flow south across the reservation from the White River. The Cheyenne River flows along the northwestern edge of Pine Ridge Reservation. The largest city on Pine Ridge Reservation is the city of Pine Ridge, South Dakota where the agency headquarters are located. Other communities include Sharps Corner, Kyle, Potato Creek, Wanblee, Long Valley, Manderson, Oglala, Red Shirt Table, Porcupine, Red Shirt, Wounded Knee, and Denby. Other small school areas include Rockyford, Wolf Creek, Loneman, and Red Cloud.

Today, the tribal membership totals 17,775. The only major city within a couple of hours driving distance from Pine Ridge is Rapid City, South Dakota, with a population of 60,000. Chadron, Gordon, and Rushville, Nebraska are closer but none have a population over 5,000.

*The following is a 1949 listing by John Colhoff of 28 bands with their leaders. It was recorded on a winter count and belonged to the Red Cloud band of Oglala. The keeper is unknown but was related to Whiteman Stands In Sight who transcribed it into English. It was given to William Powers and he published it.*

A. WAKPAMNI DISTRICT, Pine Ridge Agency Leader(s)
1. *Tapisleca (Spleen Band) Yellow Bear, White Bird*
2. *Waglohe (Loafers Band) Red Cloud*
3. *Ite Sica (Bad Faces) Red Cloud*
4. *Wolf Creek Community (not a band)*
5. *Paha Zizipi (Slim Buttes Community) (not a band)*
6. *Janjan Blaska (Flat Bottles)*
7. *Payabya (Head of the Circle) Young Man Afraid Of His Horses*

B. WHITE CLAY DISTRICT
1. *Hoka Yuta (Badger Eaters) Thunder Tail*
2. *Cankahuh'an (Saw Backs) He Dog*
3. *Unpan Gleska (Spotted Elk Band) Spotted Elk*
4. *Siksicela (Hostiles) Red Horn Bull*
5. *Tatanka Numpa (Two Bulls Band) or Ogle Luta (Red Shirt Band) Two Bulls and Red Shirt*

C. WOUNDED KNEE DISTRICT (Cankpe Opi)
1. *Oyuhpe (Untidy Band) Big Road, Spotted Owl, Flying Hawk*
2. *Man kaha (Skunk Pelt Band) Long Cat*
3. *Wanblenica (Orphans Band) Thunder Bear*
4. *(Colhoff could not remember this band)*

D. PORCUPINE DISTRICT (Pahin Sinte)
1. *Wajajes (Osage) Knife Chief, Holy Bear, Iron Cloud, Eagle Bear*
2. *Pesla (Bald Heads) White Bull*
3. *Peji (Grass Band) Jim Grass, Rock*

E. MEDICINE ROOT DISTRICT (Pejuta Haka)
1. *Kiyaksa (Cut Band) American Horse*
2. *Taopi Cikala (Little Wound Band) Little Wound*
3. *Wanbli Gleska (Spotted Eagle Band) Spotted Eagle*
4. *Tatanka Wakiyan (Thunder Bull Band) Thunder Bull*
5. *Itancan Cikala (Little Chief Band) Little Chief*

F. CORN CREEK DISTRICT
(could be part of MEDICINE ROOT DISTRICT)
1. *Mato Yamni (Three Bears Band) Three Bears*
2. *Skokpaya (Basin Band) or Matozi (Yellow Bear Band) Yellow Bear and Big Mouth*

G. WANBLI DISTRICT (Wanbli Hohpi, Eagle Nest) or PASS CREEK DISTRICT (2 separate districts)
1. *Wakpamnila (Distribution Band)*
2. *Can sa sa (Red Willow Band)*
            *Colhoff said these 2 bands were originally part of the Spleen Band.*

*The Author, Donovin Sprague*
CANHAHAKE/CANKU WANKATUYA
HUMP/HIGH BACK BONE

# One

# OYATE
## (People/Nation)

*T*he people have traveled in search of food with the buffalo being the prime source for food, shelter, and clothing. Tipis were constructed from buffalo hides. The Black Hills of South Dakota is the center of the Lakota Nation and place of origin in Lakota creation stories. The oyate group is the most important and it is the person's responsibility to be loyal to the group. Itancan leaders were only as good as their leadership and people were free to join other groups if their leader was not effective. No one person could speak for the whole group and the concept of "chief" came from the French. Although the oyate may change, it must remain strong. The Pine Ridge Reservation is divided into nine districts which include: Eagle Nest, LaCreek, Medicine Root, Pass Creek, Pine Ridge, Porcupine, Wakpamni, White Clay, and Wounded Knee.

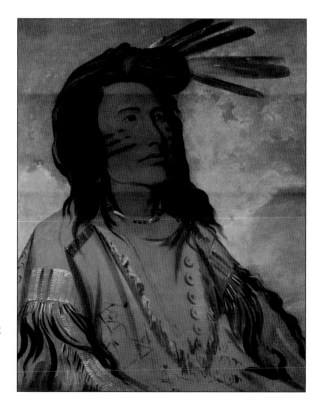

TOBACCO "CANLI" (OGLALA).
This portrait by George Catlin was sketched in 1832. Tobacco was described by George Catlin as an Oglala chief who was respected and famous among his people. His buckskin shirt was adorned with exploits from battles. George Catlin made this drawing of Tobacco near present day Fort Pierre, South Dakota when explorers met members of the Lakota/Dakota/Nakota nation. The Lewis and Clark Expedition met the tribes at this and other locations on the Missouri River. (Photograph courtesy of Bureau of Ethnology, Smithsonian.)

**UNIDENTIFIED WINYAN (OGLALA).** Photo undated. This photo is from the Lone Bear family. The dress is made of tanned bucksin with fringes and the top half of the dress is fully beaded in lazy stitch style. The moccasins are also fully beaded in the same technique, with their own design. (Photograph courtesy of Carmen Yellow Horse.)

**STABBER "WACHAPA" (OGLALA).** Photo taken in Washington D.C., 1875. The top half of this photo appeared in the *Indian Country Today* newspaper in 1996 under a large caption that reads "Is This Crazy Horse?" The photo is Stabber when he was in Washington D.C. and is not Crazy Horse. It was said that there was a scar on this man's face like the scar Crazy Horse was known to have. All of the correct information was labeled on the bottom part of this photo by the Smithsonian, but somehow the photo got cropped. The only incorrect information on the photo said Stabber was an "Oglala Dakota" which should have read "Oglala Lakota". There is no proven photo of Crazy Horse in existence. The Stabber name appears in early Lakota accounts as a headman. Cloud Shields winter count recorded the name in 1783-1784. Lewis and Clark met an Oglala Chief by this name. Francis Parkman met a chief named Stabber in 1845. (Photograph courtesy of Smithsonian Institute.)

**STANDS FIRST "TOKA NAJIN" (OGLALA).** Photo taken possibly in 1860s. (Photograph courtesy of Smithsonian Institute.)

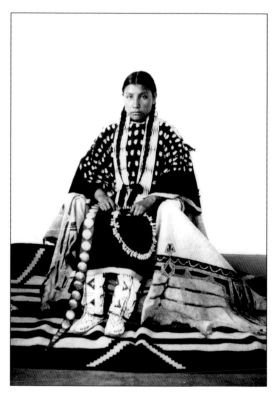

**UNIDENTIFIED LAKOTA GIRL (LAKOTA).** Photo attributed to L.R. Graves, taken *c.* 1900. This photo was taken at Pine Ridge Agency. (Photograph courtesy of Oglala Lakota College Archives and L.R. Graves.)

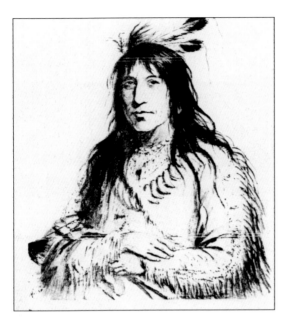

**BULL BEAR "MATO TATANKA" (OGLALA) FROM A PAINTING BY ALFRED JACOB MILLER.** Chief Bull Bear was a famous and recognized leader of about 100 lodges prior to 1841 when he was killed, likely by Red Cloud. Bull Bear's name was originally Buffalo Bull Bear and his followers were known as the Kiyuksa or Bear People. The other half of the Oglalas were known as the Smoke People, followers of Chief Smoke. Some Sicangu and northern Lakota were associated with the Oglalas at this time and took the name Oglala and joined Bull Bear. Bull Bear and Smoke feuded and when Smoke refused to fight Bull Bear, Bull Bear stabbed Smoke's favorite horse to death. It is believed that Red Cloud then took action against Bull Bear. The "politics" of this event would later enable Red Cloud to raise his position among the Oglala. Earlier, Bull Bear had killed White Hawk, uncle of Red Cloud. Bull Bear's sons were Little Wound, Spotted Eagle, Thunder Bull, and the younger Bull Bear. The children of the younger Bull Bear were Lawrence, Julie, Morris, Dickson, Peter, Jesse, Moses, Annie, Henry, Lima, Jacob, and Alice. Marcel Bull Bear provided valuable information on the Bull Bear family and their long line of prominent leaders (chiefs). The Bull Bear family is also married into the family of Man Afraid Of His Horses, another hereditary headman family. These families should be recognized for their line of headmen. (Sketch courtesy of Walters Art Gallery.)

**YOUNG MAN AFRAID OF HIS HORSES "TASUNKE KOKIPAPA" (OGLALA).** This photo was taken by W.H. Jackson, c.1870. Young Man Afraid Of His Horses was from a family of hereditary headman/shirtwearers of the Oglala. His name means that enemies are afraid of his horses. When the enemy sees his horses they become afraid because they know he is near. The family name was handed down and his father was called Man Afraid Of His Horses. His father received an honoring shirt around 1830, and was a headman of the Oglala in 1854 and leader of the Hunkpatila band. His position was taken by Red Cloud and his band was pushed aside. Man Afraid Of His Horses was present at the council of the Treaty of Fort Laramie in 1868. Young Man Afraid Of His Horses became a leader while his father was still alive and he helped negotiate a Lakota surrender with General Miles after the 1890 Wounded Knee Massacre with holdouts in the area. Young Man Afraid Of His Horses settled in the community called Payabaya (Pushed Aside), also known as Number 4 Community in Wakpamni District. Young Man Afraid Of His Horses died of pneumonia in 1893 while on his way to a Crow Indian visit in Montana. He is buried one mile northwest of Loneman School near Oglala, South Dakota. (Postcard courtesy of Donovin Sprague.)

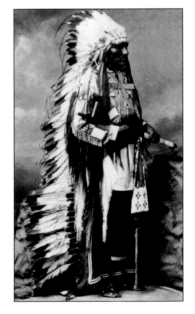

**UNIDENTIFIED MAN (LAKOTA).** This photo was taken by J.A. Anderson in 1900, and loaned to the author by Ed Two Bulls Jr. This could be a Sicangu Lakota since J.A. Anderson took many photos at Rosebud Reservation. (Photograph courtesy of Ed Two Bulls Jr.)

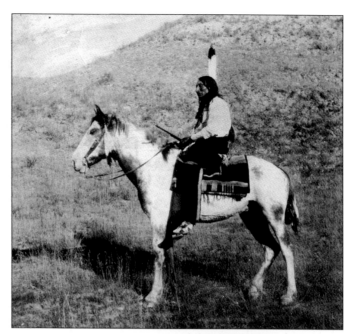

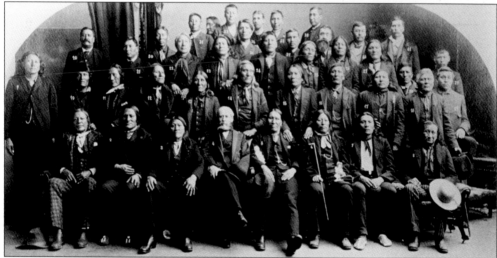

**FULL DELEGATION OF SIOUX INDIANS.** This 1891 photo was taken in Washington D.C. by C.M. Bell. Pictured from left to right are: (front row) Fire Lightning, John Grass (Hunkpapa), Two Strike (Sicangu), Commander T.J. Morgan, American Horse (Oglala), High Hawk (Minnicoujou), High Pipe, and Young Man Afraid Of His Horses (Oglala); (second row) Hollow Horn Bear (Sicangu), Crazy Bear (Oglala), Medicine Bull, White Ghost, Quick Bear (Oglala/Sicangu), Little Wound (Oglala), Fast Thunder (Oglala), Spotted Horse (Oglala), Spotted Elk (Oglala), Grass, and Dave Zephier (Yankton?); (third row) Louis Richards (French), Clarence Three Stars, Big Mane, Big Road (Oglala), Hump (Minnicoujou), Good Voice (Oglala), White Bird, He Dog (Oglala), One To Play With, and Pete Lamont (French); (fourth row) Wize, No Heart, Mad Bear (Hunkpapa), Straight Head (Cheyenne River Lakota), F.D. Lewis, Major Sword (Oglala), Turning Hawk, Robert American Horse (Oglala), Reverend Luke Walker, Bat Pourieau (Pourier) (French), Alex Rencontreau (Rencontre) (French), and Louis Shangrau (Shangreaux) (French). (Photograph courtesy of Bureau of Ethnology and Donovin Sprague.)

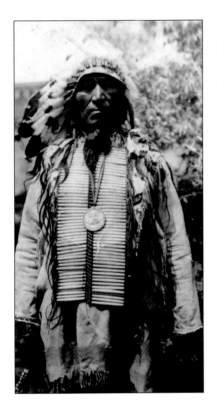

**UNIDENTIFIED WICASA (OGLALA).** This man is probably an Itancan (Chief) and wears a headdress, buckskin shirt, bone breast plate, and a presidential peace medal around his neck. (Photograph courtesy of Carmen Yellow Horse.)

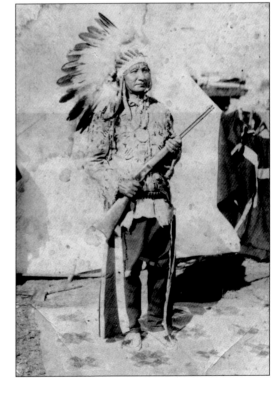

**UNIDENTIFIED WARRIOR (OGLALA).** This man is probably an Itancan (Chief) and is posed beside a tipi with his headdress, presidential peace medal around his neck, and he holds a Winchester rifle. This photo is from the Lone Bear family. (Photograph courtesy of Carmen Yellow Horse.)

**BLACK SHAWL WOMAN (OGLALA), 1888.** Black Shawl was the wife of the well-known Crazy Horse. They had no surviving children and their only daughter, Kokipapa (They Are Afraid Of Her), died about the age of six. Crazy Horse spent most of his married life with Black Shawl. His two other sometimes-listed wives, Black Buffalo Woman and the Laravie/Larive/Larrabee woman were brief affairs. Black Buffalo Woman was the wife of No Water. Crazy Horse had no children with the Laravie woman and was with her for three months at the longest. There were rumors that Black Buffalo Woman had a light haired child who some thought was from Crazy Horse but no one seems to have any record of this. Crazy Horse is remembered in this book as a great leader and warrior of the Lakota. His mother, Rattling Blanket Woman, was a full Minnicoujou Lakota and he should be recognized as a member of this Lakota band. Crazy Horse had alliances with all the Lakota bands. (Photograph courtesy of Crazy Horse Memorial Foundation and Bureau of Ethnology.)

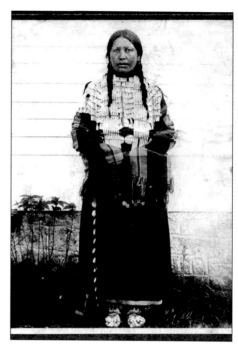

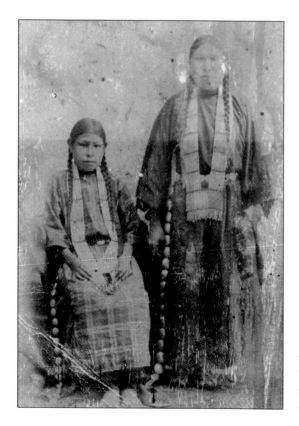

**UNIDENTIFIED WINYAN AND WICINCALA (OGLALA).** This photo is from the Lone Bear family. (Photograph courtesy of Carmen Yellow Horse.)

15

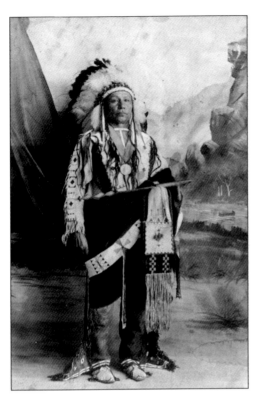

**UNIDENTIFIED WICASA (OGLALA), UNDATED.**
This man is posed in a studio and holds an elaborate pipe and tobacco bag. This photo is from the Lone Bear family. (Photograph courtesy of Carmen Yellow Horse.)

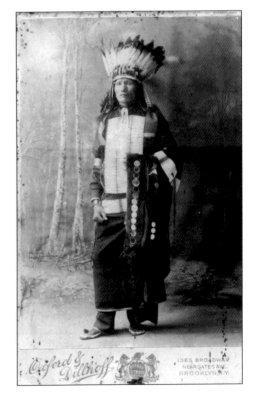

**MR. IRON WHITEMAN (OGLALA).** Photo undated. This photo is from the Lone Bear family and on the back it reads "Mr. Iron Whiteman" and on the side of the back it reads "Delphine H Horse". (Photograph courtesy of Carmen Yellow Horse.)

16

**RICHARD WHITE BULL (OGLALA).**
Photo taken by Heyn and Matzen,
c. 1900. Richard White Bull was
born in 1879 and is listed from
Porcupine District. He married Ella
Pine Bird. A son, Richard White
Bull Jr., was born in 1910 and died
in 1920 at age 10. There are other
White Bull families on other Lakota
reservations, some related and some
not related. This photo was taken
during the Indian Exposition at
Omaha, Nebraska. (Photograph
courtesy of Oglala Lakota College
Archives and Bureau of
Ethnology, Smithsonian.)

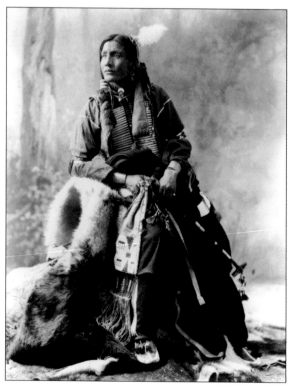

**HAS NO HORSES (OGLALA).** This
photo was taken by Heyn and
Matzen, c. 1900, at the Indian
Congress Exposition in Omaha,
Nebraska. (Photograph courtesy of
Oglala Lakota College Archives and
Bureau of Ethnology, Smithsonian.)

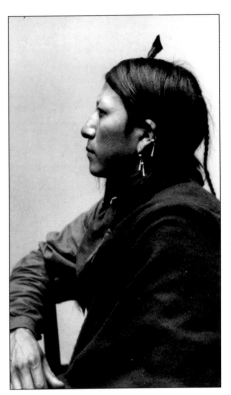

**HIGH HORSE "SUNKAWAKAN WANKAL" (OGLALA).** One of the High Horse's (Oglala) was at the Battle of the Little Bighorn. Later, three High Horse brothers were High Horse, Broken Horse, and Eagle Star. The elder High Horse brother was with Chief Two Strike's Sicangu band. Broken Rope was waiting in line on his horse at the agency to receive a name when his horse started bucking and acting up. The reins or bridle was broken so he was named Broken Rope. The brother Eagle Star received his name from a vision he had. It is thought that this latter brother was the one who went to Oklahoma and was never heard from again. Some Eagle Stars settled at Rosebud and Lower Brule. The artist Godfrey Broken Rope (born at Rosebud) is also part of this family. Godfrey's Lakota name was "Tohanni Ku Sni" (Never Returns). Paul High Horse was born in 1885 and lived at Wanblee, SD to the age of 100 (1885–1985). A grandson of his is Bryant High Horse, a kola (friend) of the author. (Photograph courtesy of Oglala Lakota College Archives and Musée de l'Homme, Paris, France and Bureau of Ethnology.)

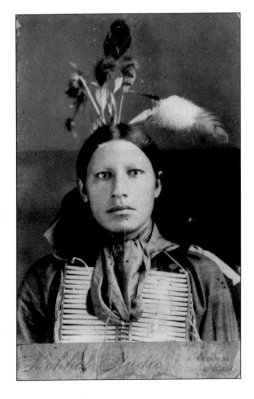

**TWO TWO (OGLALA).** Photo undated. This photo was distributed by Hohhof Studio of Chicago, Illinois. The author received information from Delphine Two Two and Newton Two Two Jr. that Newton was named after his grandfather, Newton Sr., and the father of Newton Sr. was Norbert Two Two who lived in the time period when this photo was taken. The Lakota name for Two Two was originally Two By Two. An older man was Edward Two Two, born in 1851, and he went to Europe with the Sarrassani Show where he became ill and died in Altmessen, Germany in 1914, and was buried in Dresden, Germany. Bear Foot and this Two Two were called brothers. Parents of Bear Foot were Pacer and In Center. (Photograph courtesy of Carmen Yellow Horse.)

**SAMUEL LONE BEAR (OGLALA).** This photo is undated. (Photograph courtesy of Carmen Yellow Horse.)

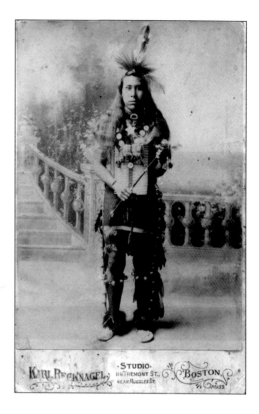

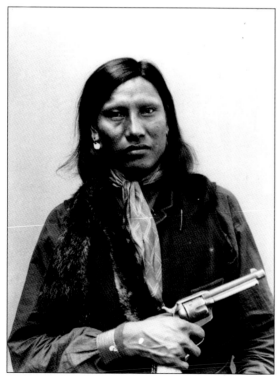

**UNIDENTIFIED WICASA (LAKOTA).** This undated photo is believed to be from Pine Ridge Agency. The man holds a Colt .45 pistol. (Photograph courtesy of Oglala Lakota College Archives and Musée de l'Homme, Paris, France and Bureau of Ethnology.)

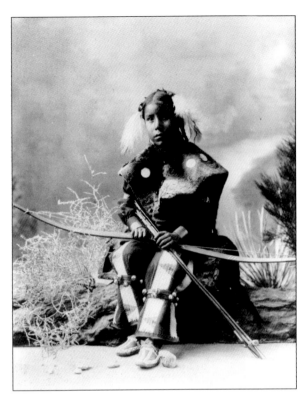

**PULLS THE BOW (LAKOTA).** This photo was taken by Heyn and Matzen, *c.* 1900, and shows a young boy with a nice bow and arrows, taken at the Indian Congress Exposition in Omaha, Nebraska. (Photograph courtesy of Oglala Lakota College Archives and Bureau of Ethnology, Smithsonian.)

**KILLS BRAVE (LAKOTA).** Taken by Heyn and Matzen, *c.* 1900, this photograph of Kills Brave was taken at the Indian Congress Exposition in Omaha, Nebraska. (Photograph courtesy of Oglala Lakota College Archives and Bureau of Ethnology, Smithsonian.)

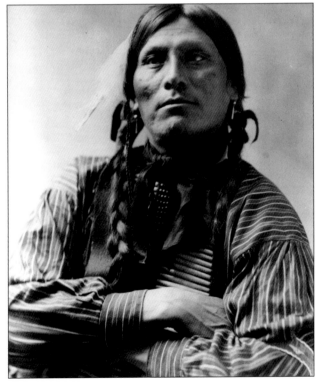

SALLY LITTLE SOLDIER "AKICITA CIKALA"
(LAKOTA). Photo taken by Heyn and Matzen, *c.*
1900. This photograph was taken at the Indian
Congress Exposition in Omaha, Nebraska.
(Photograph courtesy of Oglala Lakota College
Archives and Bureau of Ethnology, Smithsonian.)

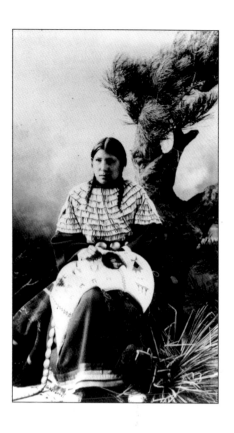

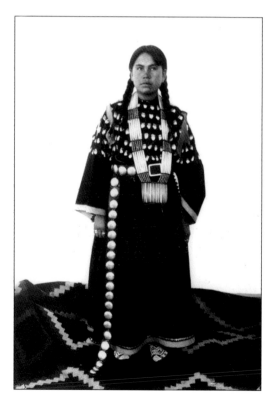

UNIDENTIFIED WOMAN (LAKOTA).
Attributed to L.R. Graves, taken *c.* 1900,
this photo was taken at the Pine Ridge
Agency. (Photograph courtesy of Oglala
Lakota College Archives and Amon Carter
Museum, Ft. Worth, TX.)

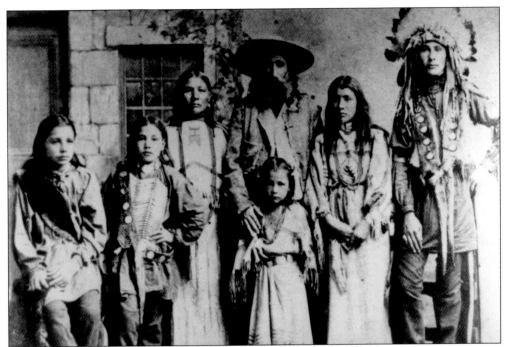

**JOHN Y. NELSON AND FAMILY (OGLALA).** The photo is dated 1880-1896. John Nelson was an interpreter, scout, and guide. He was with Buffalo Bill's "Wild West Show" and he married Red Cloud's sister. Pictured from left to right are James Nelson, Charles Nelson, Mrs. Nelson (picture states that Mrs. Nelson was Red Cloud's Sister), John Nelson, Rosa Nelson, Julia Nelson, and Thomas Nelson. A sister of John Nelson's was Jo Ecoffey. Other records show John Young Nelson married Jennie Lone Wolf about 1846 and their daughter Rose Nelson was born about 1879. If Rose is the Rosa in this picture, the picture would not date as early as 1880 but closer to 1887. (Photograph courtesy of Oglala Lakota College Archives and Chandler Institute.)

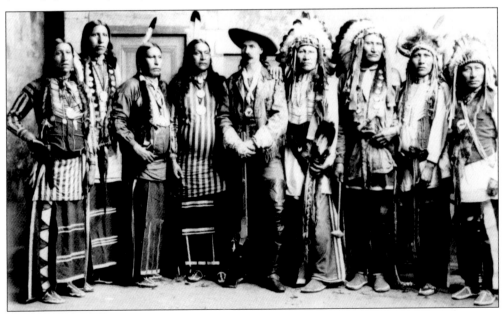

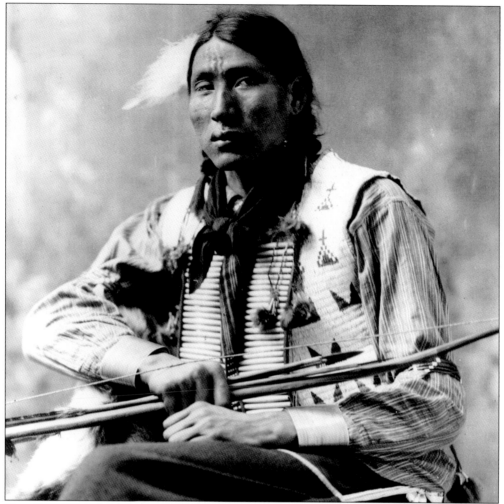

**TWO ELK "HEHAKA NUMPA" (LAKOTA).** Photo taken by Heyn and Matzen, *c*.1900. Two Elk is holding his bow and arrows in this photo taken at the Indian Congress Exposition in Omaha, Nebraska. (Photograph courtesy of Oglala Lakota College Archives and Bureau of Ethnology.)

*Opposite (bottom):* **LAKOTA MEN WITH BUFFALO BILL.** Photo taken by Anderson in 1886. William F. "Buffalo Bill" Cody is pictured with Lakota and Pawnee chiefs at Colonel Fred Cummins' Indian Congress during the Pan American Exposition in New York. Pictured from left to right: (Pawnee Chiefs) Brave Chief, Eagle Chief, Knife Chief, Young Chief, Buffalo Bill; (Lakota Chiefs): American Horse, Rocky Bear, Flys Above, and Long Wolf. Long Wolf "Sunkmanitu Hanska" became ill while on tour with the Wild West Show in Europe and died on June 11, 1892. He was buried in London. Two months later, a Lakota child named White Star (infant daughter of Ghost Dog) also died in a horse riding accident and was buried on top of the body of Chief Long Wolf. Both were returned to Pine Ridge Reservation in 1997 and were re-buried at Wolf Creek. In 1997, Jessie Black Feather was 86 years old and the oldest descendant of Long Wolf, being the granddaughter of Long Wolf. It was also learned by the tribal delegation that other Lakotas are buried in the Brompton Cemetery in London including Surrounded (died in 1887 at age 22), Red Penny (son of Little Chief, died in 1887), and Paul Eagle (died in 1891). (Photograph of Denver Public Library, postcard courtesy of Donovin Sprague.)

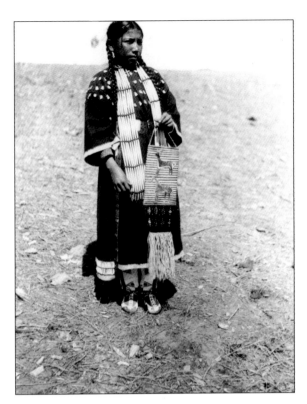

**UNIDENTIFIED WOMAN (LAKOTA).**
This undated photo was taken
on Pine Ridge Reservation.
(Photograph courtesy of Oglala
Lakota College Archives and
Bureau of Ethnology, Smithsonian.)

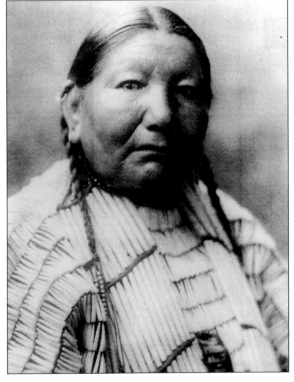

**CALLS HER NAME "CAJE CAJEYATA"**
**(OGLALA).** In this photo by Heyn,
1899, Calls Her Name has deer bone
and dentalium shell decoration as part
of her dress. As early as the late 1700s,
deer bone was being manufactured in
the eastern United States and was a
valued trade item made of substitute
material. (Photograph courtesy of
Smithsonian Institute.)

24

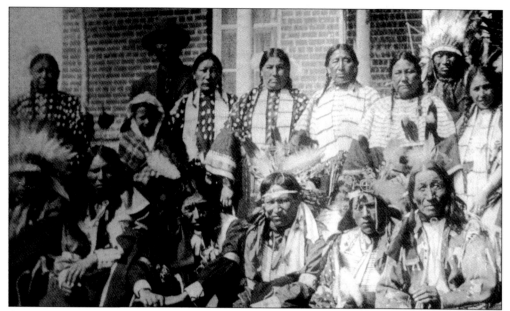

**OGLALA GROUP AT PINE RIDGE AGENCY.** In a photo taken by Edward Herbal, March 29, 1909, this group of men and women are pictured in front of the Pine Ridge Agency building in Pine Ridge, South Dakota. These buildings are still used today by the tribal government. The photographer Edward Herbal, was a German immigrant (Photograph courtesy of Alvera Wise.)

**OGLALA GROUP AT PINE RIDGE AGENCY.** Photo taken by Edward Herbal, March 29, 1909. This is a continuation of the photo at the top in front of the Pine Ridge Agency. (Photograph courtesy of Alvera Wise.)

**UNIDENTIFIED FANCY DANCER (LAKOTA).** Photo undated. This young boy is ready for the powwow to start. The photo was taken on Pine Ridge Reservation. (Photograph courtesy of Oglala Lakota College and Bureau of Ethnology, Smithsonian.)

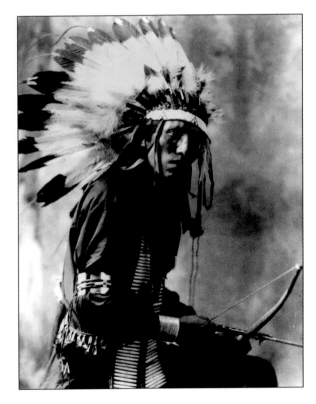

**AFRAID (LAKOTA).** This photo was taken by Heyn and Matzen, c. 1900, at the Indian Congress Exposition at Omaha, Nebraska. (Photograph courtesy of Oglala Lakota College Archives and Bureau of Ethnology, Smithsonian.)

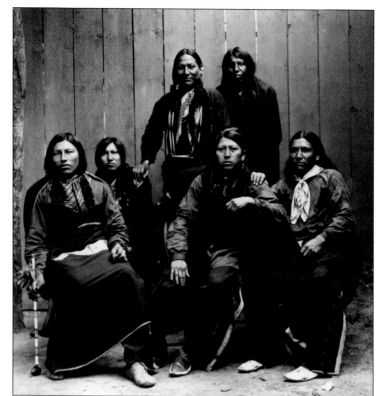

*(right)* **SIX UNIDENTIFIED LAKOTA MEN (LAKOTA).** This photo is undated. (Photograph courtesy of Oglala Lakota College Archives and Musée de l'Homme, Paris, France.)

*(below)* **LAKOTA MEN IN CEREMONY (LAKOTA).** This photo was taken in 1907 by Edward S. Curtis. The men in this ceremony are unidentified but this is recorded as the Hunka Iowanpi ceremony. They are making relatives. (Photograph courtesy of Oglala Lakota College Archives).

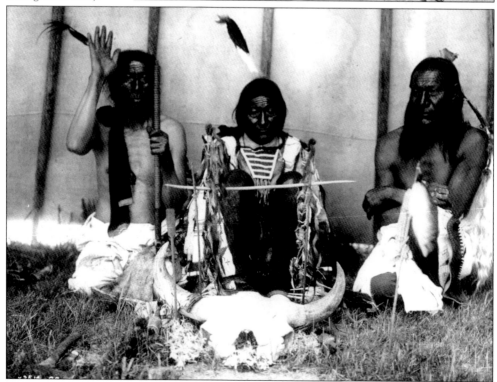

YOUNG MAN AFRAID OF HIS HORSES (STANDING) AND MAN AFRAID OF HIS HORSES (OGLALA). This undated picture of father and son was taken at Pine Ridge Indian Reservation. (Photograph courtesy of Bureau of Ethnology.)

WOMAN DRESS (OGLALA). This photo is undated. Woman Dress was born in 1846 in present day Wyoming and was the son of Old Smoke and his wife named Burnt Her. He had 4 wives, the last one being Gray Cow, who was the daughter of High Bear (d. 1860) and Yellow Hair Woman. Edward Woman Dress was a son of Woman Dress and received his land allotment near Pass Creek. Supposedly, when Woman Dress was young he was called "The Pretty One," due to his elaborate way of dressing. Later he was called Woman Dress. He was a popular man with the non-Indians at Fort Laramie. The sister of Woman Dress had a son named Louis Shangreau, and Louis and Woman Dress became scouts for the U.S. Army. Woman Dress was present during the killing of Crazy Horse and was later shot and wounded by the Cheyenne during the Cheyenne outbreak at Fort Robinson in 1879. Red Feather claimed relation to the Smoke family and said the Smoke family was part Cheyenne, and an agent was sent a telegraph message to free the Cheyenne relatives of Woman Dress who were among the Cheyenne captives at the time of the outbreak. Woman Dress lived until 1920. (Photograph courtesy of Bureau of Ethnology, Smithsonian.)

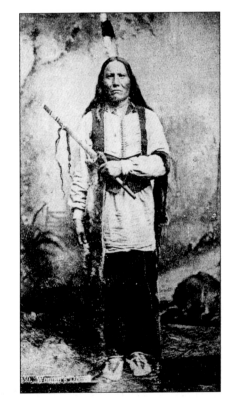

# Two

## FETTERMAN OKICIZE (Fetterman Fight)
## CANPAGMIY ANPI OKICIZE (Wagon Box Fight)
## MAGA WAKPA OKICIZE (Hayfield Fight)
## PEJI SLA OKICIZE (Battle of the Greasy Grass
## Battle of the Little Bighorn)

Oglala Lakota members are proud descendents of people who participated in every major event in Lakota history, including the people's own recorded events in winter counts before the arrival of non-Indians. Some of those are the most important but least known in history. For pictures from this era, drawings on hides and rocks exist. Oral stories are also important. Later events include: the early 1700s visit by the French explorers, the LaVerendrye brothers; the 1804 Lewis and Clark Expedition; the 1854 Grattan Incident; the 1851 and 1868 Ft. Laramie Treaties; the 1866 Fetterman Fight; Bozeman Trail Wars; the 1867 Hayfield Fight; the 1867 Wagon Box Fight; the 1876 Battle of the Rosebud (Montana); and the 1876 Greasy Grass-Battle of the Little Bighorn.

FETTERMAN FIGHT SITE, 2002. Three forts were built in the heart of Lakota territory, along the Bozeman Trail: Fort Reno, Fort Phil Kearny, and Fort C.F. Smith. This location is just north of Fort Phil Kearny where the Fetterman Fight occurred. Under orders from Colonel Carrington, Capt. William J. Fetterman led 80 men out from Fort Kearny on December 21, 1866 to relieve a wood train that was under attack by the Lakota. Carrington's orders were to relieve the wood train but not pursue the enemy beyond Lodge Trail Ridge to the north. Fetterman disobeyed orders and pursued decoy warriors over the ridge into an ambush. Fetterman had boasted that with 80 men he could ride through the entire Sioux nation. On this day, all 80 of the men perished and the majority of the soldiers made a stand around this hill. A foot trail is visible up to the hill, and the Bozeman Trail is still visible today to the right of the trail. Some of the Lakota leaders included Crazy Horse, Hump, Rain In The Face, and Red Cloud. The Bozeman Trail wars were sometimes called Red Cloud's War by the United States Government because he was a recognized Chief by the United States This is not an accurate name because Red Cloud did not direct all the Lakota in these wars and was not present at some of these wars. The Wagon Box Fight happened just west of this location in the following summer of 1867. Visitors to the site read signs explaining that Hump and Crazy Horse led this attack, coming out of the Big Horn Mountains. (Photograph courtesy of Donovin Sprague.)

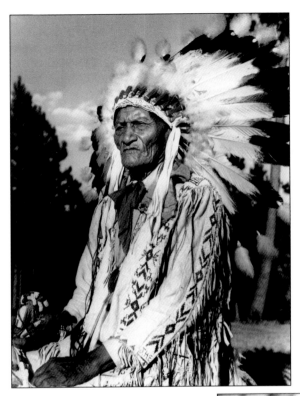

HIGH EAGLE, JOE "WANBLI WANKAL"(OGLALA). Joe High Eagle was a survivor of the Battle of the Little Bighorn and was photographed by Bill Groethe in 1948 in the Black Hills of South Dakota. He was a young boy at the time of the battle and was also a long time friend of Jimmy Comes Again who was also a survivor. Bill Groethe is now 81 years old and still operates First Photo shop in Rapid City, South Dakota. (Photograph courtesy of Bill Groethe.)

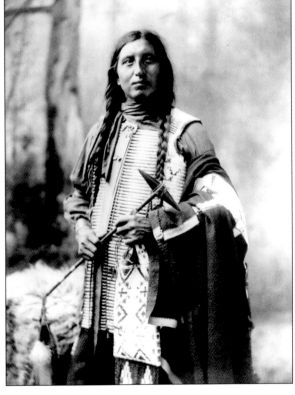

LITTLE CHIEF "ITANCAN CIKALA" (OGLALA). Photographer is unknown and the photo is undated. Little Chief was a brother of Chief Little Wound. The other brothers were Spotted Eagle, Thunder Bull, and Bull Bear (the younger one). The grandfather of Little Chief was Bull Bear (the older one). The Little Chief family also ties into the Sicangu at Rosebud Reservation. (Photograph courtesy of Smithsonian Institute.)

**CHIEF STINKING BEAR (OGLALA).** This photo was taken by Heyn and Matzen, *c.* 1900, during the Indian Exposition at Omaha, Nebraska. A more recent Lakota leader, Gerald One Feather is a descendant of Stinking Bear. Gerald One Feather served as president of the Oglala Sioux Tribe from 1970-1972. Charles Stinking Bear married Ida Stinking Bear about 1894. Ida was born in 1872. (Photograph courtesy of Oglala Lakota College Archives and Bureau of Ethnology, Smithsonian.)

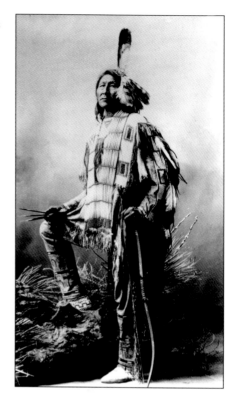

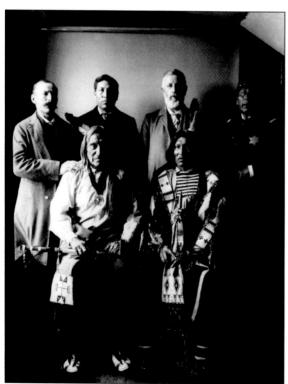

**WASHINGTON D.C. GROUP.** This photo was taken by William Dinwiddie in 1896. Pictured from left to right are: (front row) Little Wound (Oglala) and Kicking Bear (Minnicoujou); (back row) Phillip F. Wells (mixed blood interpreter), George Fire Thunder (Oglala), James A. George (non-Indian attorney), and Thunder Bear (Lakota). Kicking Bear was an Oglala but identified himself with the Minnicoujou Lakota to which his wife Woodpecker Woman belonged. (Photograph courtesy of Oglala Lakota College Archives and Bureau of Ethnology, Smithsonian.)

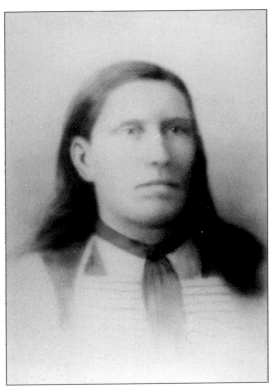

FRED TWO BULLS (OGLALA). This photo is undated. Fred was a tribal policeman and an Episcopalian. The children of Fred and Mary Two Bulls were Stern, Julian (who drowned), Margaret, Peter, Dora, and one stillborn child not named, Steven, Edward Sr., Lucy, John, Moses, Lizzie (Swallow), Jake, and Delphine (Yellow Horse). Fred Two Bulls was the grandfather of Ed Two Bulls Jr. who assisted the author with their family history. Rev. Bob Two Bulls and his wife Delores Ten Fingers-Two Bulls also assisted the author. Bob is the son of Peter Two Bulls, Sr. and Martha Helper-Two Bulls. (Photograph courtesy of Ed Two Bulls Jr.)

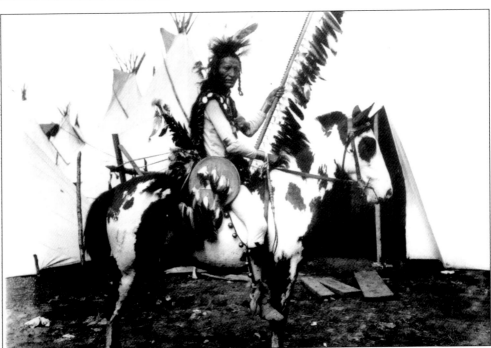

COMES OUT HOLY "WAKAN HINANPA" (OGLALA). This photo was taken by Charles H. Carpenter. This photo was taken at the St. Louis World's Fair Louisiana Purchase Exposition, which was held at St. Louis, Missouri in 1904. (Postcard courtesy of Donovin Sprague.)

**CHIEF RED CLOUD "MAHPIYA LUTA" (OGLALA).** This photo was taken by Charles M. Bell, 1880. Red Cloud was born in 1822 and became one of the most well-known leaders of the Lakota. Red Cloud received his name because a red comet traveled through the sky in the year he was born. He was appointed and recognized by the United States government. He was a great leader among his people, but the federal government had unrealistic expectations of him; they believed he could control the entire Lakota nation. The United States policy was to appoint one person as the chief spokesman for everyone, but the Lakota nation did not function in that manner. Red Cloud lived to the age of 87; he died in 1909. (Postcard courtesy of Donovin Sprague.)

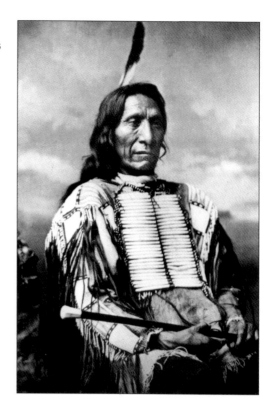

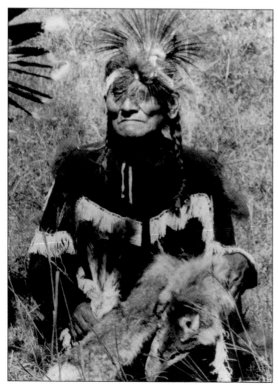

**JIMMY COMES AGAIN (OGLALA), 1948.** Jimmy Comes Again was a survivor of the Battle of the Little Bighorn. He was a young boy at the time of the battle. He was one of eight survivors who had their photo taken by Bill Groethe at a reunion in the Black Hills of South Dakota. Jimmy Comes Again was related to the Two Bulls family and stayed with them at Red Shirt Table. His wife was Nancy who was a sister of Mary Alice One Crow-Two Bulls. Mary was Mrs. Fred Two Bulls. (Photograph courtesy of Bill Groethe.)

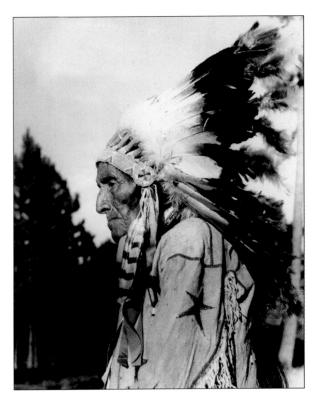

**PEMMICAN "WAKAPAPI WASNA" (OGLALA).** This 1948 photo was taken in the Black Hills of South Dakota by Bill Groethe when Pemmican and seven other survivors of the Battle of the Little Bighorn gathered for a reunion. Pemmican was a young boy at the time of the Little Bighorn. (Photograph courtesy of Bill Groethe.)

**CHIEF EAGLE BEAR (LAKOTA).** Photo undated. Eagle Bear was the son of Chief Knife Chief and Follows Prairie Fire Woman. Eagle Bear married Jennie Cloud Shield. Jennie was the daughter of Cloud Shield and Martha Chasing Enemy. Eagle Bear also fought at the Little Bighorn on June 25, 1876. A daughter of Eagle Bear and Jennie Cloud Shield is Mabel Eagle Bear who married Robert Pumpkin Seed. Another daughter was Helen Eagle Bear who married Philip Good Shield. A son named Louis Eagle Bear died at an early age. Chief Eagle Bear is the great grandfather of Francis He Crow. (Photograph courtesy of Francis and Michael He Crow.)

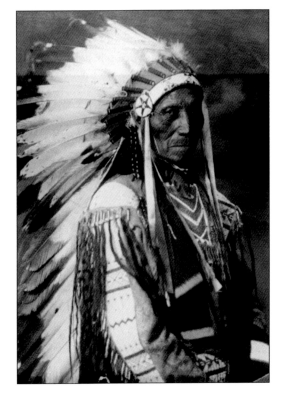

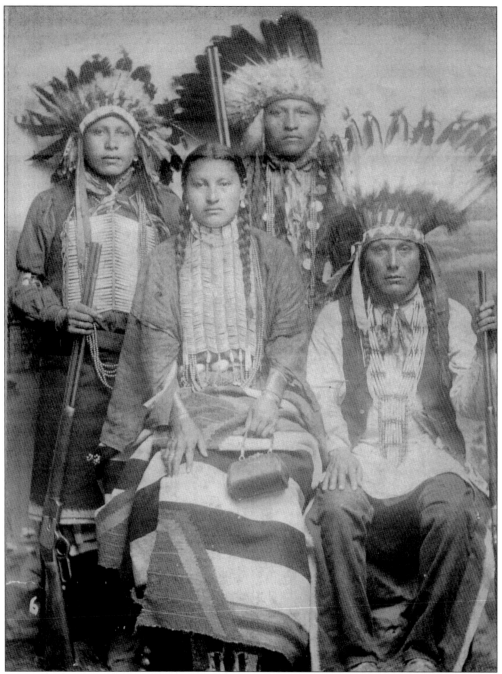

LONG FEATHER, HAIL STONES IN HER STOMACH, RAIN IN THE FACE, AND YELLOW BULL, (LAKOTA). This undated photo was labeled as Sioux braves from Pine Ridge Agency, Dakota Territory. All were said to have been at the Battle of the Little Bighorn on June 25, 1876. Hail Stones In Her Stomach is listed as the wife of Long Feather. She is seated in the front, with Long Feather probably seated next to her. This Rain In The Face does not appear to be the famous Hunkpapa warrior who had the same name, and was also at the battle. (Photograph courtesy of Claire Heldman.)

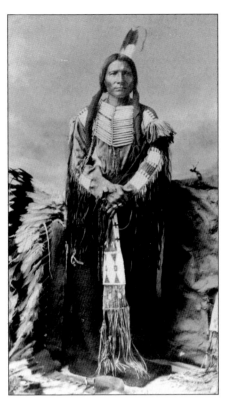

**LITTLE BIG MAN "WICASA CIKALA TANKA" (OGLALA).** This photo was taken by Charles M. Bell in 1877. Little Big Man was a respected leader who fought along with Crazy Horse against the U.S. Cavalry. Little Big Man was also known by the following names: Pursuing Bear, Chasing Bear, and Charging Bear. Little Big Man was in opposition of the treaty and commission which was trying to take the Black Hills, and whose commission was in violation of an existing treaty. Following his surrender in 1877 with Crazy Horse, Little Big Man then became an Indian Policeman at Red Cloud Agency. During the attempted arrest of Crazy Horse, Little Big Man was among those that tried to restrain him and Crazy Horse was killed during this struggle. Some historians and museums present that Little Big Man killed Crazy Horse. Others, such as the author, believe it was the soldier that stabbed Crazy Horse in the back while Little Big Man and another soldier held Crazy Horse at each arm. The drawings of the historian Bad Heart Bull show the latter story to be correct. A soldier by the name of William Gentles may have stabbed Crazy Horse. (Postcard courtesy of Donovin Sprague.)

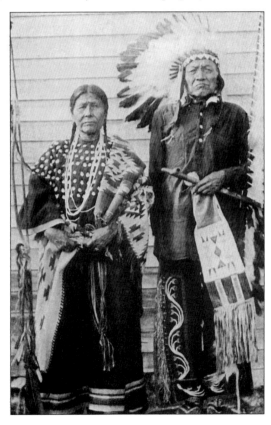

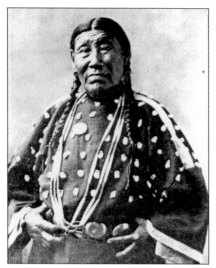 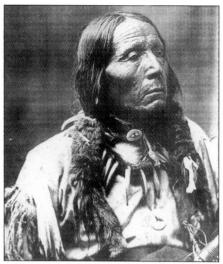

*(left)* SUSIE SHOT IN THE EYE (OGLALA). Photo taken by F.A. Rinehart, *c.*1899. Susie Shot In The Eye was the wife of Mashed Fingernails. Shot In The Eye, who participated in the Battle of the Little Bighorn in 1876, was a family member of Susie's from an earlier generation. She wears beaded necklaces and the yoke of her dress is adorned with elk teeth (ivory), of which there are only two per elk. The Two Dog and Lone Hill families are descendants of Susie Shot In The Eye. (Photograph courtesy of Bureau of Ethnology, Smithsonian.) *(right)*SHOT IN THE EYE "ISTA OPI" (OGLALA). Photo taken by Heyn and Matzen, *c.* 1900. Shot In The Eye is a veteran of the Battle of the Little Bighorn. He lost his eye as the battle was ending. A ball from a soldier's musket had been fired and hit Shot In The Eye in his left eye. It was told that the ball dazed him as he had already quit fighting. After being hit in the eye he became disgusted and returned into the battle ground to fight again and count coup. This picture was taken in Omaha at the Indian Congress Pan-American Exposition. Rick Two Dogs and the Lone Hill family of Porcupine, South Dakota, are descendants of this family. (Photograph courtesy of Bureau of Ethnology, Smithsonian.)

*(opposite)* HORN CHIPS "PTEHE WOPTUHA" AND MRS. CHIPS, (OGLALA), 1907. Horn Chips was also known as Encouraging Bear, His Leggings, Chipps, Chips, and Old Man Chipps. Horn Chips was born in 1824 along the Bad River, close to Fort Teton, the Oglala trading post at the mouth of the Bad River and lived until Jan. 4, 1916. He spent his early years in the territory between the Missouri River and the Black Hills. Later he often camped in the Rapid Creek and Bear Butte area. He was a member of the Stone Dreamers and was a prominent medicine man. His family died when he was young, so he was raised by his grandmother. He had a friendship and link to many people, including Chief Crazy Horse. A wife of Horn Chips was Her Good Horse and their sons were Geoffrey Chips, Moves To Camp (Moves Camp), and Horn Chips. His daughter was Alice Chips. All three sons became respected medicine men. Sam Moves Camp is the son of Moves Camp and his wife. Erma Maldonado is the great great granddaughter of Horn Chips "Woptuha". Erma's grandparents are Oliver Jack and Alice Chips Jack. Geoffrey Chips married Comes Back Hard and their son was Andrew Chips. Andrew Chips married Ophelia Red Hoop, and their daughter is Avena Chips. Three sons of Ellis Chipps and his wife Victoria are Charles Chipps, Phillip Chipps, and Godfrey Chipps. Horn Chips was interviewed by Peter Schweigerman, an interpreter, at Chips' home the year this photo was taken and Chips talked about the life of Crazy Horse. Chips was on Beaver Creek, south of Spotted Tail Agency when Crazy Horse fled there just prior to his death. Chips was also interviewed in 1913 through 1915 about the final resting place of Crazy Horse. (Photograph courtesy of Bureau of Ethnology, Smithsonian and Chipps family).

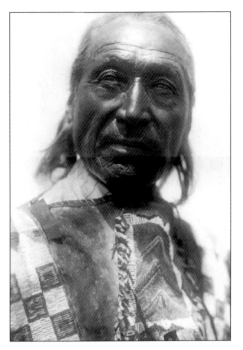

**HE CROW "KANGI BLOKA"(MINNICOUJOU).**
This photo was taken by Edward S. Curtis. He Crow was the brother of He Crow who was killed at the Wounded Knee Massacre. Their father was Si Tanka (Big Foot), who was also killed at the massacre, and their mother was Small Tail (Sinte Cikala), who received two flesh wounds in her left thigh at the massacre. As a result of this, she died of pneumonia a couple of weeks later, on January 13, 1891, at the age of 60. The children of Si Tanka and Small Tail were Yellow Horse (also known as Yellow Haired Horse and Yellow Hair), Pipe On Head, and He Crow. Si Tanka (Big Foot) was originally known as Spotted Elk and led his band of Minnicoujou to Wounded Knee in December of 1890. When Spotted Elk/Si Tanka (Big Foot) arrived at Cheyenne River Agency, he had a sore foot and one moccasin was made larger for that foot, and he then became known as Big Foot. The father of Si Tanka (Big Foot) was Chief Lone Horn also known as One Horn, and the mother of Si Tanka was Tate Yuha Win. This family line goes into the family of Chief Crazy Horse, whose mother Rattling Blanket Woman, was a Lone Horn/One Horn. One Horn (Lone Horn) had seven wives, three of whom were sisters. Then his son, Si Tanka (Big Foot), also had seven wives. (Photograph courtesy of Francis and Michael He Crow.)

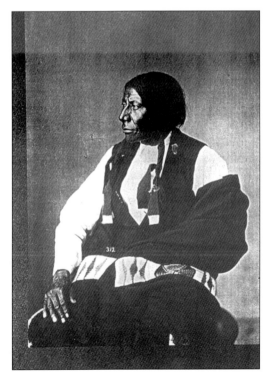

**BLUE HORSE "SUNKAWAKAN TO" (OGLALA), UNDATED.** This is one of many photos labeled by the Smithsonian as an Oglala Dakota. The correct name would be Oglala Lakota, with the Dakota being a group of the eastern Teton. (Photograph courtesy of Bureau of Ethnology.)

**ALICE BLUE LEGS "HU TO" (OGLALA), UNDATED PHOTO.** Alice Blue Legs was a well-known quillwork artist who grew up on Pine Ridge Reservation. She attended the government school at Grass Creek and lived with her husband, Emil and their five daughters. Alice gave demonstrations and workshops at Dartmouth, Buffalo Bill Historical Center at Cody Wyoming, and the Sacred Circle in Kansas City. She sold her works to collectors in France, Germany, and Canada. Her work has been displayed at the Heard Museum in Arizona, and a permanent display is maintained by the Indian Arts and Crafts Board in Washington D.C. The National Endowment for the Arts, Folk Arts Program, named Alice Blue Legs as a recipient of a National Heritage Fellowship. The Blue Legs are now both deceased. The author was taught the technique of Lakota quillwork by Alice and Emil. (Photograph by H. Jane Nauman, courtesy of Donovin Sprague.)

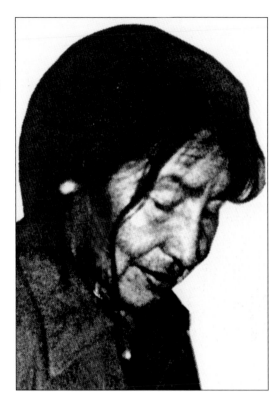

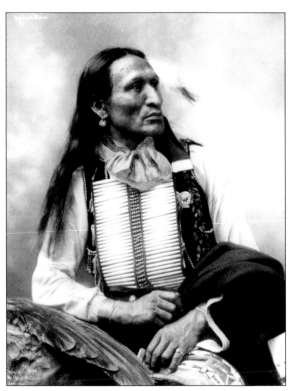

**WHITE MAN BEAR "WASICUN MATO" (OGLALA), 1899.** This photo, taken by Heyn, was likely taken at the Indian Exposition held at Omaha, Nebraska in 1899. (Photograph courtesy of Smithsonian Institute.)

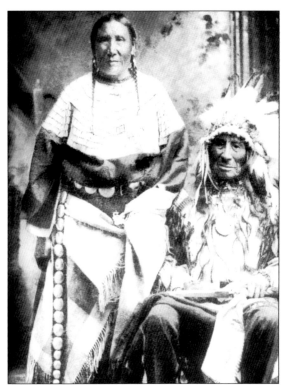

**BAD WOUND "OO SICA" (OGLALA) AND ROSIE RED TOP, HIS WIFE.** This photo is undated. Bad Wound, a leader of the Southern Oglalas from 1853 to about 1870, moved to Pine Ridge Reservation and went south into Nebraska each winter. About 1900 he became ill on a trip south and asked the Lessert family near Batesland if his wife, Rosie Red Top, could stay with them. He died soon after and Rosie stayed with them until she died in 1935 or 1936. Bad Wound was a peaceful leader whose band ranged from the Republican River north to the Platte River. Forced to leave their hunting grounds on the forks of the Kansas River, the Southern Oglalas moved north to the White River area where they were the first to settle in the Corn Creek area of Pine Ridge Reservation. (Photograph courtesy of John Artichoker.)

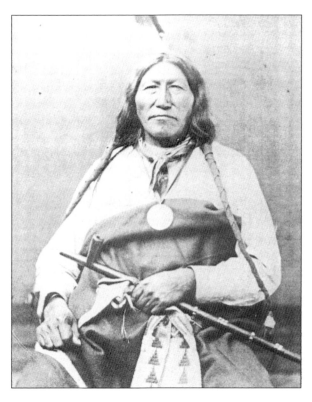

**HE DOG "SUNKALALOKA" (OGLALA).** This photo was taken in Washington D.C. in 1877 when He Dog traveled to Washington with a delegation of leaders. He was born about 1840 and died in 1936 at the age of 96 years. Bad Heart Bull was a brother of He Dog's, according to a 1930 interview He Dog gave with Thomas White Cow Killer as an interpreter. He Dog was the nephew of Red Cloud. (Photograph courtesy of West Point Military Academy.)

**HE DOG "SUNKALALOKA" (OGLALA).** In 1928 or earlier, an unknown photographer took this photo of He Dog in front of this log home on the Pine Ridge Reservation. (Photograph courtesy of Oglala Lakota College Archives and Bureau of Ethnology, Smithsonian Institute.)

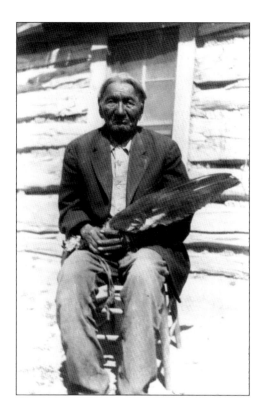

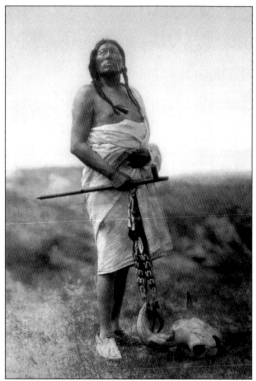

**SLOW BULL "PTEBLOKA SLOHAN" (OGLALA).** In a photo taken by Edward S. Curtis in 1907, Slow Bull is pictured here with a pipe with a buffalo skull on the ground at his feet. Edward Curtis took many photos of American Indian people throughout the United States. (Postcard courtesy of Donovin Sprague.)

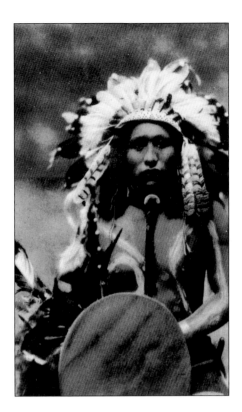

LONE ELK "ISNALA HEHAKA" (OGLALA),
UNDATED. Lone Elk is pictured here in traditional
dress. (Postcard courtesy of Donovin Sprague.)

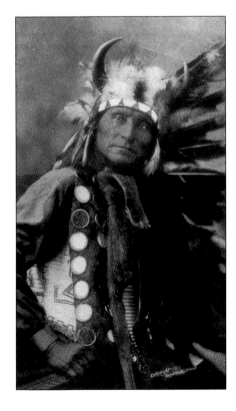

LITTLE HORSE "SUNKAWAKAN CIKALA"
(HUNKPAPA). This photo was taken by Heyn in
1899. Little Horse was a participant at the Battle
of the Little Bighorn where he had two fingers
shot off his left hand. He was a Hunkpapa Lakota
but he quarreled with his relatives following
the killing of Sitting Bull and then joined the
Oglala band. He was also at the Wounded Knee
Massacre in 1890. This photo was taken at the
Indian Exposition in Omaha, Nebraska. (Postcard
courtesy of Donovin Sprague.)

CHIEF TALL CRANE "HOKA HANSKA" (LAKOTA), UNDATED. This is a Paul C. Koeber Co. 1-cent postcard. (Postcard courtesy of Donovin Sprague.)

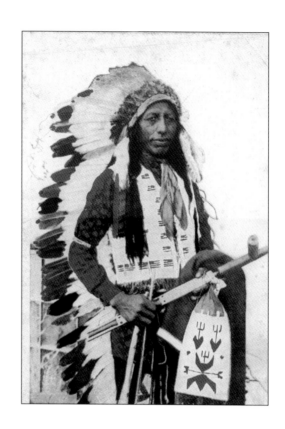

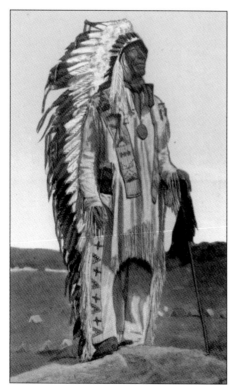

ALBERT CRAZY HORSE (OGLALA), POSTCARD #61 BY BLACK HILLS POST CARD CO., DEADWOOD, SOUTH DAKOTA, UNDATED. This is a drawing of Albert Crazy Horse that confuses people because of its claim to be Chief Crazy Horse. The postcard is labeled "Old Chief Crazy Horse, A Leader in the Sioux Indian Wars, Black Hills, S.D." This man was named Greasing Hand and took the name Crazy Horse when he married the Larrabee/Larvie/Laravie woman at Fort Robinson following the killing of Chief Crazy Horse. (Postcard courtesy of Donovin Sprague.)

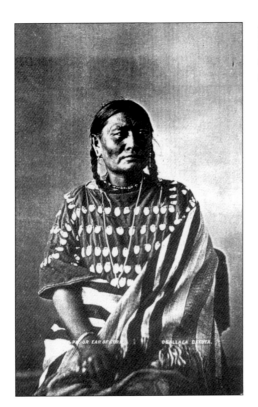

**EAR OF CORN (OGLALA), UNDATED.** Ear Of Corn is listed as the wife of Lone Wolf. Her dress is adorned with elk teeth. (Photograph courtesy of Smithsonian Institute.)

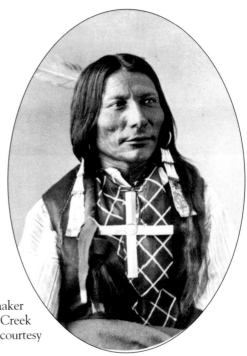

**LONE WOLF (OGLALA).** Photo taken by Wanamaker in 1913. The Lone Wolf family lived in the Pass Creek District at Pine Ridge Reservation. (Photograph courtesy of Bureau of Ethnology.)

HENRY LONE BEAR "MATO WANJILA" (OGLALA), c. 1909. This photo was taken by Geoffrey Duncan. Henry Lone Bear was the son of Oliver Lone Bear "Mato Wanjila," who was born in 1849 at Pass Creek. His mother was Plenty Brothers "Tibloku Ota," who was born in 1853 at Pass Creek. Their other children were Susie Lone Bear (born in 1894), Foot (a son born in 1857), and Samuel Lone Bear (born in 1879). (Photograph courtesy of Denver Public Library.)

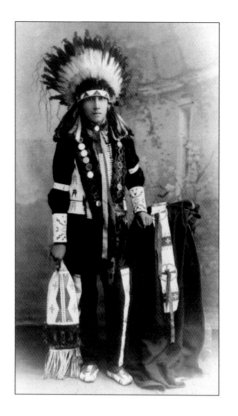

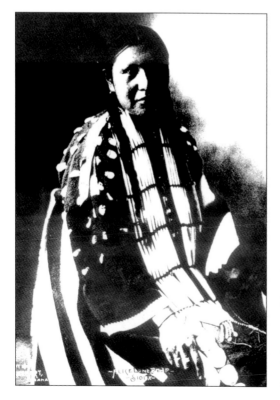

ALICE LONE BEAR (OGLALA). This photo, taken by F.A. Rinehart, c. 1890, shows Alice, the wife of Oliver Lone Bear "Mato Wanjila;" her maiden name was Plenty Brothers "Tibloku Ota." She was born in 1853 at Pass Creek and her children were Henry Lone Bear, Susie Lone Bear, Foot, and Samuel Lone Bear. (Photograph courtesy of Bureau of Ethnology.)

45

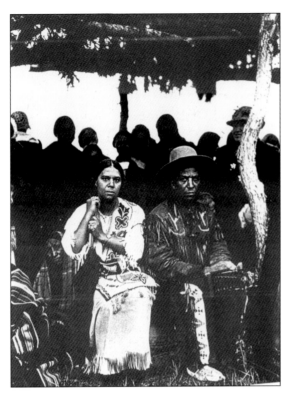

STAR COMES OUT (HUNKPAPA/ OGLALA), UNDATED. This photo was labeled only as "Patty Star's Great Grandfather." They originate from the No Water family. The origin of the Star Comes Out name was told in the book *Black Elk Speaks* in which two girls gazed into the night sky admiring a big star and a little star. Each one had a preferred star and agreed to marry the two stars. The girls returned home and were then visited by the two stars in the form of an old and young man who took them away to their supernatural and sacred "wakan" lands as wives. The story continues over many pages. Photograph courtesy of Oglala Lakota College.)

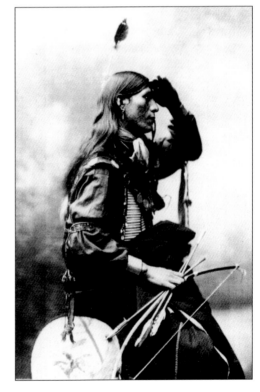

THOMAS NO WATER "MINI WANICA" (HUNKPAPA/OGLALA). This photo by Heyn was taken *c.* 1899. Thomas No Water was born in 1879 and was the son of No Water. The No Water who married Black Buffalo Woman was born bout 1840. They were married around 1865, and two of their children are listed as "No Water," one born around 1866 and one born around 1868. Crow Woman was also a wife of No Water, and Crow Woman was the mother of Ed Star Sr. A wife named Black Crow is also listed on census rolls with No Water. The author visited with Stephen Starr in 2001. Stephen, Ed, and Ivan Starr are brothers. (Photograph courtesy of Oglala Lakota College.)

**OLIVER LONE BEAR "MATO WANJILA" (OGLALA).** This photo was taken by Heyn and Matzen *c.* 1900. Oliver was born in 1849 and this picture was taken when he was about 51 years old. He married Plenty Brothers "Tibloku Ota" and she became known as Alice Lone Bear. Their sons were Henry Lone Bear, Samuel Lone Bear, and Foot, who was possibly an adopted son. Their daughter was Susie Lone Bear. Sandor Iron Rope, whom the author visited with, is a great grandson of Oliver and Alice Lone Bear. (Photograph courtesy of Bureau of Ethnology.)

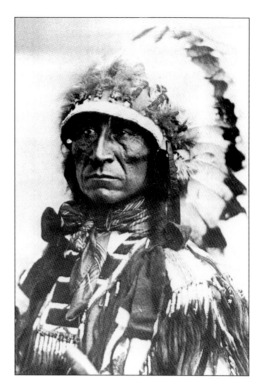

**LITTLE WOUND, HIS WIFE, AND SON (OGLALA).** Photo taken by Heyn and Matzen in 1899. The Little Wound family consisted of his wife, Tells Lies, and daughters, Won't Give Up Blanket and Jennie Little Wound; the sons were George Little Wound, Andrew Little Wound, and James

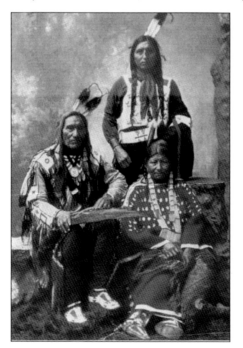

Little Wound. The son in this photo is probably George but could also be James, according to their known age. Two more children died in infancy. Little Wound was from the Bear People band of Oglala and a treaty signer. He was born August 30, 1830 and was the son of Chief Bull Bear. His brothers included Spotted Eagle, Thunder Bull, Bull Bear (the younger one), and Little Chief. He married Tells Lies prior to 1862. A nephew of Little Wound's was Sitting Bull, the Oglala. This Sitting Bull was not related to the well-known Sitting Bull of the Hunkpapa Lakota. In the 1860s, Little Wound's mother found an African-American child in a ravine in what is now Nebraska. This child was adopted into the home of Little Wound and they taught him the Lakota language. This child's name was Alexander Baxter and he said that he was with a party of slaves going west and had been lost. Alexander is buried a few feet southeast of the resting place of Chief Little Wound at St. Barnabas Episcopal Cemetery, one mile south of Kyle, South Dakota. (Postcard courtesy of Donovin Sprague.)

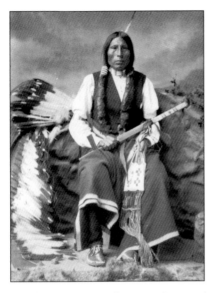

**SWORD (OGLALA), UNDATED.** The name Sword was taken during the early agency period, with the first name of George added later. Born in Bull Bear's camp in 1847, the year in which Eagle Crow was stabbed, prior to surrender, Sword was known as Hunts The Enemy. He was a nephew of Red Cloud and participated in the Battle of the Little Bighorn. When he surrendered at Camp Robinson he volunteered to lead a delegation to induce Crazy Horse to surrender. Woman Dress assisted him in this mission, but they failed. Crazy Horse did surrender later, in May of 1877. Sword was also known by the name Long Knife. At the agency, George Sword became the first captain of the Indian police and was the first judge of the Court of Indian Offenses. The Oglala shirtwearer by the name of Sword was George Sword's brother. Brave Bear was a brother of Red Cloud, and Sword was the son of Brave Bear. Sword traveled for a while with Buffalo Bill Cody. When the reservation was established he became a leader, an Episcopalian catechist, and was given credentials to be a representative-at-large. Jessie Sword-Running Horse, a survivor of the Wounded Knee Massacre, was adopted by George Sword. Jessie married Pete Running Horse. Sword had no other children and died at age 63 in 1910. (Photograph courtesy of Bureau of Ethnology.)

**AMERICAN HORSE (OGLALA), 1898.** This photo was taken by F.A. Rinehart. There are several people named American Horse. This is not the American Horse (Minnicoujou/Itazipco Lakota) who was killed at the Battle of Slim Buttes following the Battle of the Little Bighorn. He is sometimes referred to as the older American Horse. There was also an American Horse who was a Cheyenne and surrendered at Fort Robinson. This man, American Horse the younger (1840-1908), was the son of Sitting Bear, and when his father died he became chief of the Oglala True Band. Agent McGillycuddy also appointed this American Horse as a head chief when the agent was trying to diminish the power of Chief Red Cloud.

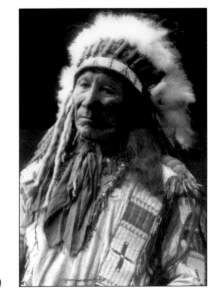

He later toured with Buffalo Bill Cody and the "Wild West Show." This is not the American Horse who was an appointed shirtwearer of the Oglala during the era of Chief Crazy Horse. Records the author obtained show Sitting Bear and his wife, Walks With Her, had a son named Matthew American Horse, (born c. 1831 and died in 1908). Matthew's wife was Fanny American Horse (born about 1851). Their children included Lucy American Horse and Alice Vina American Horse. Alice married Joseph C. Pereau in 1909. The following are some different generations of Chief American Horse provided by Loretta Afraid Of Bear in 2000. Chief American Horse's son was Charlie American Horse, Charlie's daughter was Louisa Kills Crow, and Louisa's son was Joe American Horse. The next generation also included Bill, Dave, and Martha American Horse. This photo of American Horse was taken at the Trans-Mississippian and International Exposition in Omaha, Nebraska. (Photograph courtesy of Bureau of Ethnology.)

**IRON TAIL "SINTE MAZA" (OGLALA).** Photo taken by DeLancey Gill in May 1913. Iron Tail was in Lakota wars in the Black Hills and was also an aide to Sitting Bull. In later photos such as this one, he became the model for the Indian head/buffalo nickel. (Photograph courtesy of Bureau of Ethnology.)

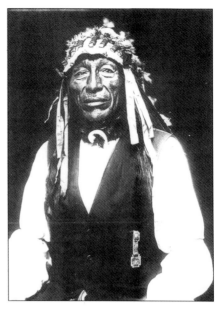

**NO NECK ? "TAHU WANJINI" (HUNKPAPA)1877.**
This photo has been circulated as a photograph of Chief Crazy Horse. It is not Crazy Horse, and there is no other proven photo of him. There are proponents who say he was photographed at Fort Robinson but an elaborate studio with a tile floor was not at Fort Robinson while Crazy Horse was there. The photographer Mr. Hamilton took pictures in the Black Hills, passed through Fort Robinson, and took pictures of a temporary grave site of Crazy Horse at "Spotted Tail Agency." The few proponents of this theory also say there is a darkened side of his face where the scar he had is visible. Studio lighting caused many photos to show a darkened side of the face. Other pictures of No Neck resemble this picture. The No Neck family ties are to the Standing Rock Sioux (Hunkpapa Lakota). No Neck is often listed as an Oglala and is on the surrender list with Crazy Horse's band in 1877 at Red Cloud Agency/Camp Robinson. The No Neck name appears on the Standing Rock census and No Neck lived in Canada with groups such as Sitting Bull. No Neck later traveled with Buffalo Bill's "Wild West Show." The No

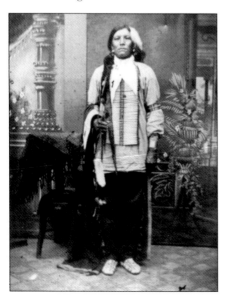

Necks were mainly from Standing Rock and married into the Oglala and Minnicoujou. Family members said the older generations would definitely be called Hunkpapa, and the later family descendants could be classified as Hunkpapa/Oglala/Minnicoujou. Today, some of the family are still on the Standing Rock land lease records but are now enrolled at Pine Ridge Agency. Other records show No Neck as the son of Smoke and Brown Eyes. No Neck was with the Wild West Show and one of his traveling companions was Peter Dillon. No Neck was also an Indian scout at the time of the Ghost Dance movement. Author George Hyde wrote an account of a narrow escape by No Neck and his nephew Louis Shangreau in a Ghost Dance camp. After the Wounded Knee Massacre, No Neck found a baby boy alive at the massacre site. Both parents were killed and No Neck raised the boy, naming him John No Neck. No Neck's grandniece was Mary Shangreau. (Postcard courtesy of Donovin Sprague.)

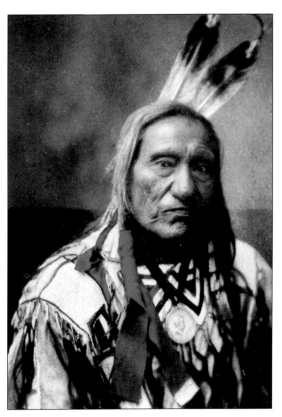

**LITTLE WOUND "TAOPI CIKALA" (OGLALA).** This photo by Heyn and Matzen taken in 1899 shows Chief Little Wound, a well-known leader, council spokesman, and son of Chief Bull Bear. He participated in four delegations to Washington D.C. in 1875, 1877, 1888, and in 1891. Little Wound was a proponent of education to create a brighter future. His son George Little Wound, He Dog, American Horse, and others brought Little Wound School to Kyle, South Dakota and four other schools to the Pine Ridge Reservation. Chief Little Wound died on July 8, 1901 and is buried south of Kyle, South Dakota. The Heyn and Matzen photos of Little Wound were taken at the Indian Congress Exposition in Omaha, Nebraska. (Postcard # 397 courtesy of Donovin Sprague.)

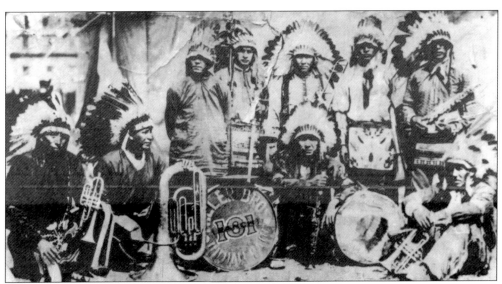

**101 INDIAN BAND.** This photo is probably the 101 "Wild West Show," and the drum may read "Miller Bros. 101 Indian Band". This photo is from an Oglala family that may have had relatives or people they knew in the show. There was a 101 show based in Ponca City, Oklahoma. (Photograph courtesy of Alvera Wise.)

PAINTED HORSE "SUNKAWAKAN WIYUN" (OGLALA). This photo was taken by Heyn and Matzen in 1901. Painted Horse was also called Sweater. He was attending the Indian Congress Pan American Exposition meeting in Omaha, Nebraska at the time this photo was taken. Painted Horse was pictured later in 1909 at Earl's Court, England when he toured with Buffalo Bill's "Wild West Show." The author has worked with the great grandson of Painted Horse, John Brewer. (Photograph courtesy of Smithsonian Institute.)

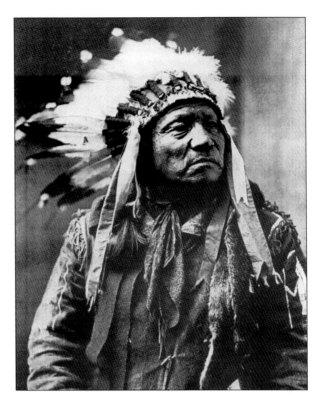

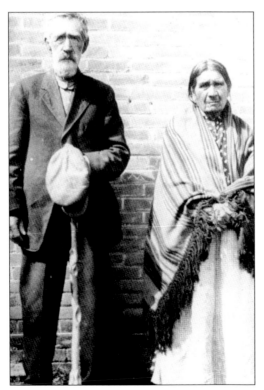

BAPTISTE "BIG BAT" POURIER (FRENCH) AND JOSEPHINE RESHAW/RICHARDS (OGLALA). Photo undated. Baptiste was born in 1841 in St. Charles, Missouri to Joseph Pourier and Marie Aubuchan L'Arbe. When Big Bat was 14 or 15 he met John Richard (Reshaw) whom he worked for. John would become his father-in-law. Big Bat and Josephine had 12 children in the army under General Crook as a guide. Big Bat's friend was called Little Bat Garnier and served with Crook as a scout. Big Bat Pourier lived at Fort Robinson. The family is related to Red Cloud. When Bat and Josephine's children John and Lizzie were married they had a double wedding ceremony and Bat's friend Teddy Roosevelt attended and danced with the brides. Josephine was born in 1854. (Postcard by Rushmore Photo, postcard from Donovin Sprague.)

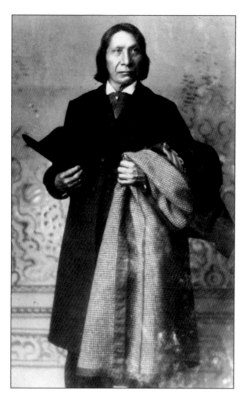

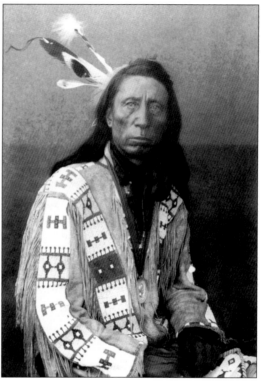

RED CLOUD "MAHPIYA LUTA" (OGLALA). This photo was taken by Choate in January 1883. Red Cloud visited the Carlisle Indian School at Carlisle, Pennsylvania to visit Lakota and American Indian students attending the school. He was en route to Washington D.C. when this photo was taken in January of 1883. He also visited New York City. (Photograph courtesy of Cumberland County Historical Society.)

JACK RED CLOUD "MAHPIYA LUTA" (OGLALA). This photo taken by Rodman Wanamaker in 1913 shows Jack Red Cloud, born in 1862, who was the son of Chief Red Cloud. Jack was a good orator but never achieved the recognition as a great Itancan (leader) that his father tried to pass on to him. Jack lived until 1928 through difficult years of transition to reservation life. (Postcard courtesy of Donovin Sprague.)

*Opposite:* SITE OF RED CLOUD AGENCY #2. This is the site of the Red Cloud Agency, which served the Oglala from 1873 to 1877. The agency issued government goods and food to 13,000 Lakota, Cheyenne, and some Arapaho who camped here. Pictured here are students from the author's classes at Oglala Lakota College and Black Hills State University on a field trip. The stone monument they are standing beside is all that is left of the Red Cloud Agency, as it has been dismantled. The prominent buttes are to the north, and just about a quarter of a mile to the northwest of where the students stand was the guardhouse on the fort parade grounds, where Chief Crazy Horse was stabbed in the back and slowly died. A newer parade ground was rebuilt in later years on the north side of the present highway. Fort Robinson is just west of Crawford, Nebraska. (Photograph courtesy of Donovin Sprague.)

# Three

# Mahpiya Luta Owakpamni
## (Red Cloud Agency)

Camp Red Cloud Agency was established March 2-7, 1874, near Red Cloud Indian Agency. On March 19, 1874, Lieutenant Robinson was killed and Camp Red Cloud Agency was renamed Camp Robinson. In May 1874, Camp Robinson moved one and one-half miles west of the agency. In June 1874, an order was issued for a permanent structure at the camp by Captain William Jordan. The last major Lakota leaders surrendered from the Powder River area in a two-week time period in late April and early May of 1877. They included Dull Knife (Cheyenne), Hump, Crazy Horse, Touch The Cloud, and Lame Deer. They were all were split up by the United States government. Dull Knife was sent to Oklahoma. Hump joined General Nelson Miles for a while but then took his band to freedom in Canada, west of the Sitting Bull camp. Crazy Horse surrendered on May 6th at Camp Robinson. Touch The Cloud was sent to Spotted Tail Agency, which would evolve into Rosebud Reservation. Lame Deer was the last to be captured of this group, in early May 1877. He was killed during the attempted capture and surrender of his band. Crazy Horse was stabbed in the back while under arrest at Camp Robinson as he was trying to escape from being placed in the guardhouse on September 5, 1877.

On October 25, 1877, Red Cloud Agency moved for the third time to a new site on the Missouri River. The fourth move was to Pine Ridge, which is its present location. When Nebraska was becoming a state, they pushed the Red Cloud and Spotted Tail Agencies into what was then Dakota Territory.

In October 1878, the Cheyenne escaped from Indian Territory to attempt to return to their Montana homeland. Dull Knife and 149 people were captured and held at Camp Robinson. By December 1878, Camp Robinson had been renamed Fort Robinson. Then, on January 9, 1879, the Cheyennes attempted to escape from Fort Robinson where they were being held and many were killed a short distance to the northwest of Fort Robinson. A Northern Cheyenne Reservation would soon be created for these allies of the Lakota in Montana, and those who remained in Oklahoma were named Southern Cheyenne. By the early 1880s, Sitting Bull and Hump came in from Canada, and eventually were placed on their home reservations of Standing Rock and Cheyenne River. Touch The Cloud was also sent to his home agency at Cheyenne River. By this time, the Oglalas were all at Red Cloud Agency.

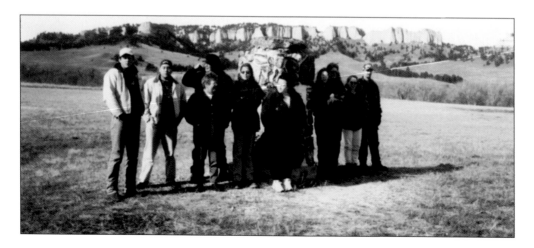

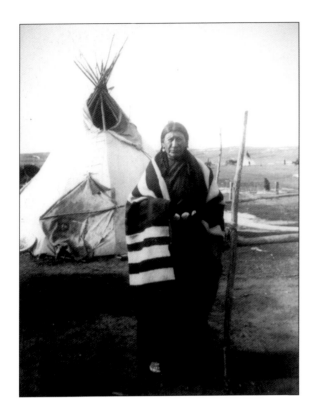

LEAN WOMAN "WE-TAMAHECHA" (OGLALA). This photo was taken by James Mooney in 1893. Lean Woman was a wife of Chief Red Cloud. (Photograph courtesy of Oglala Lakota College Archives and Bureau of Ethnology, Smithsonian.)

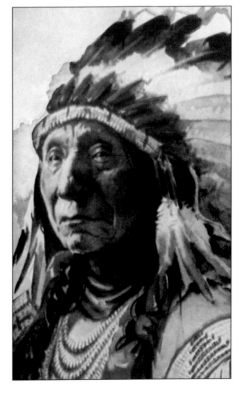

CHIEF RED CLOUD "MAHPIYA LUTA" (OGLALA). Red Cloud is depicted here in original postcard #5705. Red Cloud's daughter Louise "White Thunder Woman" married Peter Richard. The Richard/Richards name evolved from Reshaw, and "Big Bat" Pourier married Josephine Richard, who was a sister of Peter Richard. (Postcard courtesy of Donovin Sprague.)

**BLACK CROW (OGLALA), UNDATED.** This photo from the Haddon Photo Collection was identified as "Old Man Black Crow" by Zona Fills The Pipe on April 29, 1985. Black Crows were related to the No Water family. (Photograph courtesy of Oglala Lakota College Archives.)

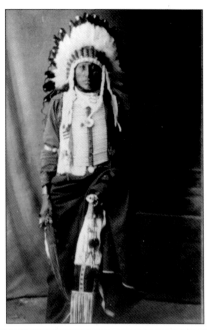

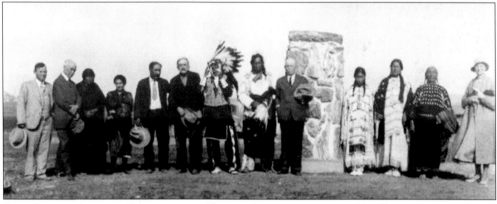

**RED CLOUD AGENCY DEDICATION.** Photo taken on May 9, 1932. The group is gathered here for the dedication of the stone monument erected on the site of the Red Cloud Agency, Nebraska in 1932. Today, the closest town is Crawford, Nebraska in northwestern Nebraska. Pictured are, from left to right: Karl L. Spence (publisher of *Northwest Nebraska News* in Crawford); A.E. Sheldon (secretary of the Nebraska Historical Society, Lincoln); Mrs. James H. Red Cloud; Mrs. Joe Richards, Joe Richards (interpreter and grandson of Chief Red Cloud); John J. "Zither Dick" Boesl (possibly the last living man who saw Chief Crazy Horse killed); John Kills Above (son-in-law of Chief Red Cloud); Chief James H. Red Cloud (grandson of Chief Red Cloud); James H. Cook (of Agate Ranch); Agnes Red Cloud (great granddaughter of Chief Red Cloud); Mrs. Charley Red Cloud; Mrs. John Kills Above (only living daughter of Chief Red Cloud); Mrs. Karl L. Spence (regent of Captain Christopher Robinson, Chapter D.A.R. of Crawford, responsible for erection of the monument). Agnes Red Cloud, the young woman to the right of the monument, is the mother of Lula Red Cloud. Next to her is Laura Red Cloud, who married Charlie Red Cloud. Next to Laura is Mrs. Kills Above who was Susan Red Cloud before marriage, the sister of Chief Red Cloud, and grandmother of Lula Red Cloud. Lula Red Cloud and Harry Burk live near Hermosa, South Dakota today, and are friends of the author. (Photograph courtesy of Denver Public Library.)

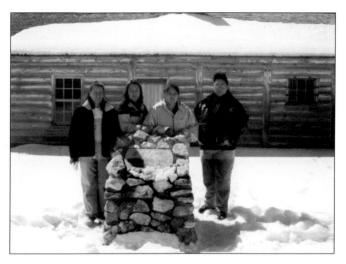

**CRAZY HORSE GUARDHOUSE AT FORT ROBINSON.** Taken March 26, 2002, this photo shows the rebuilt guardhouse where Chief Crazy Horse was stabbed at Fort Robinson. Crazy Horse began to enter the guardhouse and then turned and ran outside into a group of his own followers, Indian policemen, and soldiers. He wore a red blanket from his waist to his feet and drew a knife as he was jostled out the doorway. Crazy Horse cut the Lakota policeman Little Big Man on the wrist in the scuffle, and then he may have retrieved a second knife from someone else's sheath. He was finally held on each side by his arms with a soldier on one side and Little Big Man on the other side. Another soldier, possibly William Gentles, then thrust his bayonet into the back of Crazy Horse. Touch The Cloud was the Minnicoujou first cousin of Crazy Horse, and had arrived with Crazy Horse from the Spotted Tail Agency where Crazy Horse had fled. Touch The Cloud was described as a seven-foot tall bodyguard of Crazy Horse, and after the stabbing Touch The Cloud insisted that the body of Crazy Horse be placed next door in the adjutants office instead of being placed in the guardhouse to die. This wish was honored, and Touch The Cloud remained with Crazy Horse until death came. They had just surrendered but were now disarmed and defenseless. Crazy Horse died as a result of internal bleeding.

Buildings have been rebuilt at Fort Robinson, including the Cheyenne Outbreak barracks building. The adjutant's office where Crazy Horse died was just south of this guardhouse, and the Cheyenne Outbreak building was south of the adjutant's office building. An original photo of the guardhouse shows it had a little porch on the front. (Photograph courtesy of Donovin Sprague.)

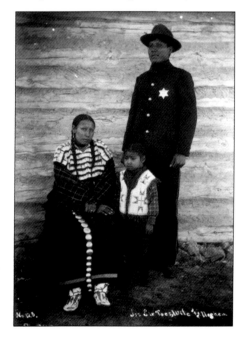

**JOE SIX TOES, MRS. SIX TOES, AND NEPHEW (OGALA).** Joe Six Toes was an Indian Policeman and is pictured here with his wife and nephew. (Photograph courtesy of Oglala Lakota College Archives and Denver Museum of Natural History).

**FLAT IRON? RACE HORSE? GREASING HAND? ALBERT CRAZY HORSE? (LAKOTA).** H.W. Daley, Chief Packmaster at Fort Robinson, said this photo, taken at Fort Robinson in 1876, was Crazy Horse. It is not Crazy Horse. Author Stanley Vestal identified this man as Flat Iron, and photographer D.F. Barry stated in 1926 that this man is Race Horse. In 1924, the U.S. War Department cataloged this photo. Novelist and Crazy Horse biographer Mari Sandoz said this man is Greasy Head, an Oglala who married Crazy Horse's woman, Nellie "Helen" Laravie/Larvie/ Larrabee. He took the name Albert Crazy Horse after the chief's death. I think the Greasy Head they refer to is a translation of Greasing Hand. Albert Crazy Horse used the names Race Horse and Greasing Hand. There was also the name Greases The Fingers, which could be a translation variation of the same name. Some family members of Albert say it is not him. (Photograph owned by Donovin Sprague, a U.S. Army Military History Institute photo.)

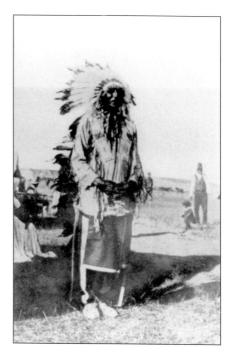

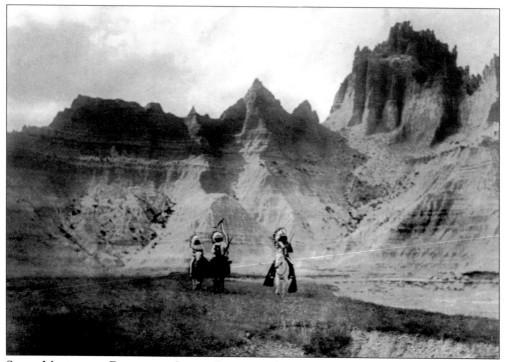

**SHEEP MOUNTAIN, BADLANDS, SOUTH DAKOTA.** Sheep Mountain was a prominent and sacred area of the Badlands on Pine Ridge Reservation. It sits southwest of the town of Scenic, South Dakota and was photographed by Edward Curtis in 1904 with the three men riding horseback in the foreground. (Postcard courtesy of Donovin Sprague.)

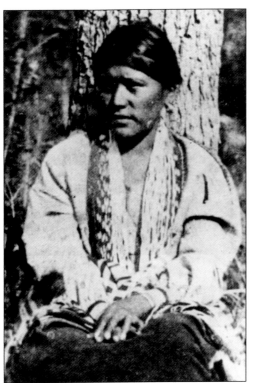

HELEN "NELLIE" "ELLEN" LARRABEE/ LARIVE/LARVIE (CHEYENNE/FRENCH), UNDATED. Helen was known by many names. Her father, Long Joe Larrabee was a French blacksmith at Fort Robinson. Her mother, "Chi-Chi" or Shahunwinla (Cheyenne Woman), was from the Cheyenne tribe. Helen had three other sisters, all who were very attractive women. While Chief Crazy Horse was under surrender at Fort Robinson he met Helen and she moved into his lodge. Crazy Horse was with her for a very brief time. He surrendered in May 1877 and was killed while under surrender on September 5, 1877. There were no children between Crazy Horse and Helen. Following his death, Helen's next husband took the Crazy Horse name. Helen's sisters were Sarah "Sally" (first husband was Scotty Philip and second husband was Louis Moran), Julia "Susie" (husband was Mike Dunn), and Zoe "Geo" (husband was James "Cornie" Utterback). After Chi-Chi died, Long Joe married Susan Metcalf. (Photograph courtesy of Smithsonian Institute.)

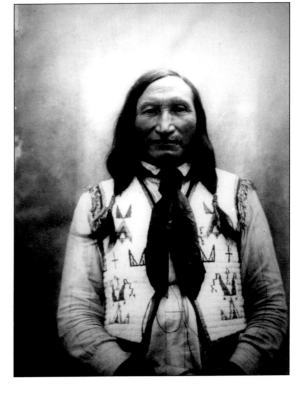

BAD COB (OGLALA). This photo was taken by DeLancey Gill, August 1907. Bad Cob wears a fully beaded lazy stitch style vest with a non-traditional shirt. The photo reflects the early reservation style of dress from 1907. (Photograph courtesy of Oglala Lakota College Archives and Smithsonian Institute.)

**STANDING BEAR, STEPHEN (MINNICOUJOU), UNDATED.** Stephen was born about 1859 and settled south of Manderson, SD near Paha Ska Hill on Pine Ridge Reservation. He married Louise Renick, a German woman, about 1888. Their children were Hattie Standing Bear-Pourier "Red Bird Woman" (b. 1889), Lillian Standing Bear-Tobacco "Blue Star Woman (b. 1892), and Christina Standing Bear-Two Bonnet-Mesteth "Two Bird (b. 1897). His wife Louise was named "Mni Winca" to refer to "across the water woman." Stephen and his friend Nicholas Black Elk told stories to John G. Neihardt for the book *Black Elk Speaks*, and Stephen drew illustrations and is pictured in several places in the book. The author works with Christina's daughter Freda Mesteth Goodsell and she remembers the pretty flowers in front of the large Standing Bear home. Freda's father is a first cousin to Ellen Black Elk, wife of Ben Black Elk. This Standing Bear family descends from a family not related to George, Luther, and Henry Standing Bear but today's descendants could have become related from later marriages. (Postcard courtesy of Donovin Sprague.)

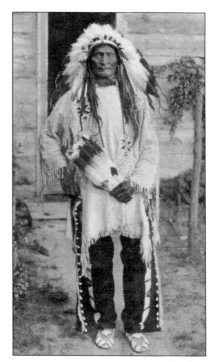

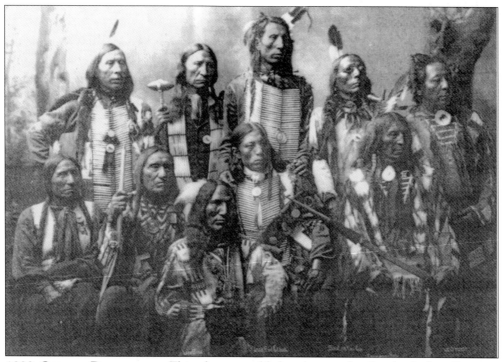

**1899 OGLALA DELEGATION.** This photo was likely taken at the Omaha Indian Congress Exposition by Heyn in 1899. Pictured, from left to right, are: (seated) Black Bear, Little Wound, Black Bird, High Hawk, and Conquering Bear; (standing) Hard Heart, Lone Bear, Jack Red Cloud, Shot In The Eye, and Last Horse. (Photograph courtesy of Bureau of Ethnology.)

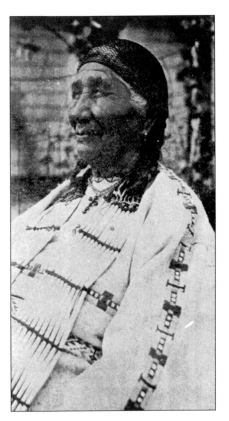

MARY TWO BULLS (OGLALA?), UNDATED. Mary was born in 1874 and was the wife of Fred Two Bulls. They lived at Red Shirt village. Her maiden name was Mary One Crow, and they married about 1890 at Rosebud. Mary's family goes back to Brave Heart who married Bird Heart. Other names on her side of the family include White Bowl and Blue Cloud, Red Horn Buffalo and Good Woman, and Joe and Fannie White Plume. (Photograph courtesy of Donovin Sprague.)

VICTORIA HUNTER-SHERMAN (OGLALA/ SICANGU), 1900. Victoria Hunter was the daughter of Henry Hunter and Lucy Standing Bear. Lucy Standing Bear was a sister of Luther Standing Bear who was a Hollywood actor and author of the books My People, The Sioux and Land of the Spotted Eagle. Another well-known Hollywood Lakota actor was Eddie Little Sky. In this picture, Victoria is dressed in traditional style and holds a feathered staff. (Photograph courtesy of Crazy Horse Memorial Foundation and Luther Standing Bear Collection.)

**MARTIN THUNDER HAWK (HUNKPAPA), UNDATED.** The Thunder Hawk family came down from the Standing Rock area and settled in Porcupine District. Notes on this family come from Chubb Thunder Hawk, Martin Thunder Hawk Jr., and Corbin Conroy, all descendants of Thunder Hawk. The first name "Martin" has remained within the family for a few generations. One Martin Thunder Hawk lived from 1927 until 1981. The community of Thunderhawk, South Dakota is named for an older Chief Thunderhawk, possibly the father or grandfather of this Martin Thunder Hawk. (Photograph courtesy of Corbin Conroy.)

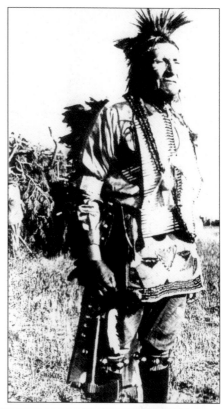

**BELOW: DELEGATION OF SIOUX INDIANS (OGLALA).** In this photo taken in Washington D.C., pictured from left to right are as follows: (front row) Yellow Bear, interpreter Jose Merrival (French), interpreter Billy Garnett (French/Lakota), interpreter Leon Pallardy, and Three Bears; (back row) He Dog, Little Wound, American Horse, Little Big Man, Young Man Afraid Of His Horses, and Hunts The Enemy (also known as George Sword). (Photograph courtesy of Oglala Lakota College Archives and Bureau of Ethnology.)

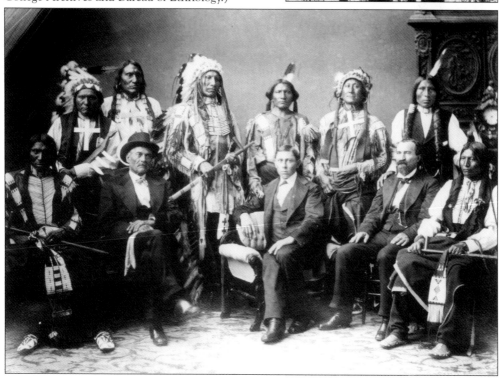

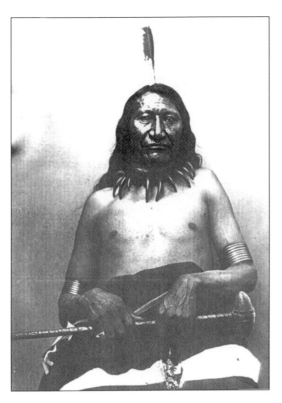

**PLENTY BEAR "MATO OTA" (OGLALA), UNDATED.** Plenty Bear was from Allen, South Dakota. (Photograph courtesy of Musée de l'Homme [Museum of Mankind], Paris, France and Oglala Lakota College).

**SIX FEATHERS "WIYAKA SAKPE" (OGLALA), UNDATED.** Six Feathers is pictured here as an Indian Policeman. He was from Allen, South Dakota. Many of the Six Feathers' family members settled at Pass Creek. Some records show that John Six Feathers and his wife Josephine were both born in 1880. Their daughters were Mollie (born in 1897), Sallie (born in 1903), and another child who was still living when these records were compiled around 1999. Other Six Feathers are James Six Feathers, who was born in 1894, and Albert Six Feathers, who was born in 1905. (Photograph courtesy of Oglala Lakota College Archives and Musée de l' Homme [Museum of Mankind] Paris, France and Bureau of Ethnology.)

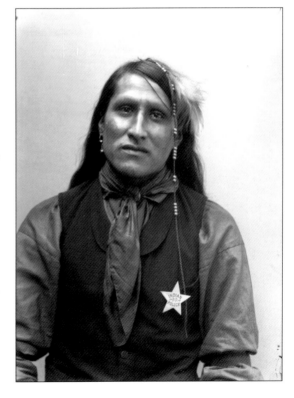

**LITTLE HORSE "TASUNKE CIKALA" (HUNKPAPA).** This photo was taken by George Heyn in 1899. Little Horse was considered an Itancan (Chief) among the Oglala Lakota, although he was a Hunkpapa. (Postcard courtesy of Donovin Sprague.)

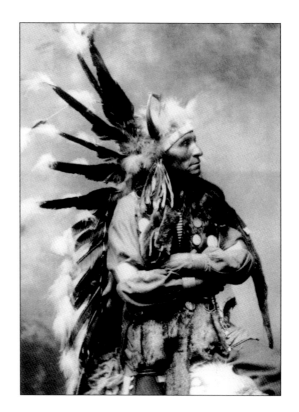

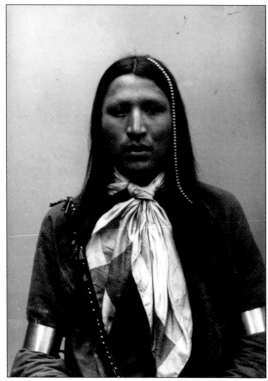

**PLENTY CROW (OGLALA), UNDATED.** Plenty Crow was from the community of Allen, South Dakota. (Photograph courtesy of Oglala Lakota College Archives and Musée de l' Homme, Paris and Bureau of Ethnology.)

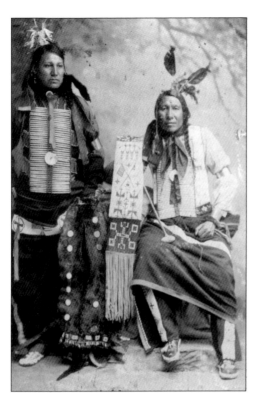

AMOS LITTLE (OGLALA) AND CHARLES CHASE CLOSE TO LODGE (LAKOTA), C. **1895.** The men are displaying a Lakota pipe bag made of beads and porcupine quillwork. The designs are a traditional geometric style and incorporate American flag designs on the bag. (Photograph courtesy of Oglala Lakota College Archives and Chandler Institute, Mission, S.D.)

CHIEF YELLOW BOY "HOKSILA ZI" (OGLALA). Photo taken by Heyn and Matzen, *c.* 1899. The author visited with Madeline Yellow Boy in 2001 and discussed the fact that Charlie Yellow Boy, an Oglala, married Josephine Fly from Sisseton. The next generation was Grover Yellow Boy from Wolf Creek and Edith Two Dogs. Madeline Yellow Boy is the only child of Grover and Edith, and Madeline married Frederick Martin. Madeline's mother Edith had the maiden name of Holy Horse and Edith's mother was Helen Holy Horse who was Lakota/ Cree. Edith's father was John Two Dogs. The son of John Two Dogs and Helen Holy Horse was Asa Two Dogs who married Edna Lonehill. Their son is Rick Two Dogs of Porcupine, South Dakota. This photo of Yellow Boy could be Charlie or a brother of his. (Photograph courtesy of Bureau of Ethnology.)

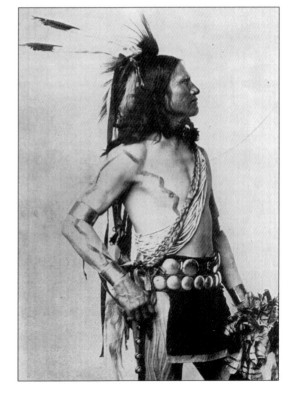

**PICKET PIN (OGLALA/SICANGU).** In this photo taken by Edward S. Curtis in 1907, Picket Pin is offering prayer while holding the pipe with a buffalo skull on the ground in front of him. (Postcard courtesy of Donovin Sprague.)

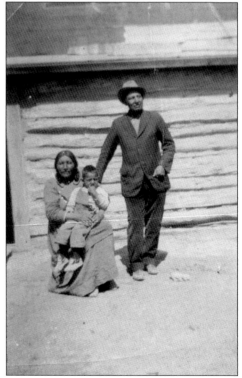

**EUGENE NO WATER (STANDING), GRANDMA LOUISA SWORD-NO WATER (SEATED), THOMAS NO WATER (YOUNG BOY), (HUNKPAPA/OGLALA), UNDATED.** Pictured here are grandparents Eugene and Louisa, with Grandma Louisa holding Thomas No Water. (Photograph courtesy of Francis and Michael He Crow.)

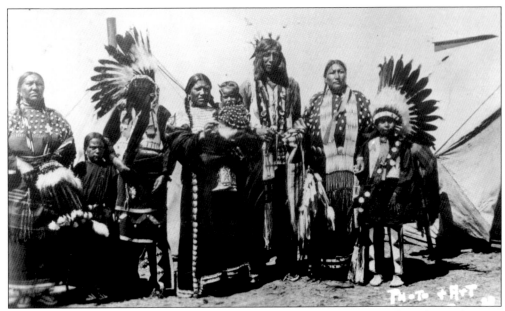

UNIDENTIFIED LAKOTA GROUP (LAKOTA), UNDATED. This postcard reads "Valentine, Neb." It could have been taken there, or by a Valentine-based studio. (Postcard courtesy of Donovin Sprague.)

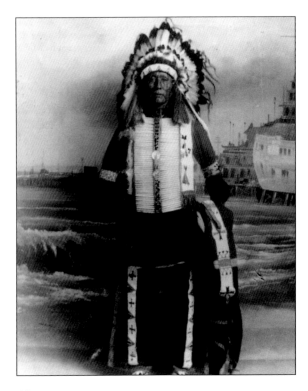

ANDREW KNIFE (LAKOTA), UNDATED. A caption on the photo says this was Chief Eagle Bear's brother. (Photograph courtesy of Francis and Michael He Crow.)

# Four

# WANAGI WACIPI NA CANK'PE OPI
## (Ghost Dance and Wounded Knee)

*P*rincipal leaders of the Ghost Dance at Pine Ridge Reservation included Kicking Bear, Short Bull, and No Water. Each had large numbers of followers of the Ghost Dance religion, which they learned about from a trip to the Pauite Ghost Dance leader, Wovoka. There was some variation of the Ghost Dance among different Plains tribes. The main prophecy was that the white man would disappear, and the tribes' deceased relatives, along with the buffalo would return. This religion and movement grew out of times of extreme pressure and change for the Plains tribes as they were being confined to reservations.

For the Lakota, Chief Sitting Bull was a main proponent of the Ghost Dance religion at Standing Rock Reservation to the north. Sitting Bull did not get along with the agent there, and the agent ordered Ghost Dancing to cease. Non-Indians thought that when dancing started it meant war—they had no knowledge of the religious aspects of the Ghost Dance.

Agent McLaughlin ordered the Indian Police to arrest Sitting Bull, whom the agent thought was a trouble maker. In a highly volatile situation, Sitting Bull was killed on December 15, 1890, along with his son and other followers, as the Indian Police attempted to arrest him in his home south of Bullhead, South Dakota. Ghost Dance religious followers then fled to the south in fear, and joined Chief Hump at Cheyenne River Reservation near Cherry Creek, S.D. Chief Hump and Chief Si Tanka (Big Foot), also known as Spotted Elk, were principal Ghost Dance leaders there. By this time, soldiers were pursuing the group, and General Nelson Miles sent a representative to ask Chief Hump to bring in his large group of followers to Fort Bennett on the Missouri River. He did this, but some of his band went to the nearby camp of Si Tanka and headed south to Pine Ridge Reservation to see Chief Red Cloud. It was thought that the Si Tanka group would surrender, but they left before dawn for their journey from Takini-Bridger to the Badlands. As they traveled south, about 356 band members were intercepted at Porcupine Butte on the Pine Ridge Reservation by Major Whitside. The group was taken about two miles southwest to an area where Colonel Forsyth began disarming them. Suddenly a shot broke out and a massacre ensued: about 300 band members were shot down by guns and cannons.

On January 3, 1891, following a raging blizzard, a burial party dug a mass grave and stacked the frozen dead bodies inside a pit without ceremony. The Wounded Knee Massacre marks the end of an era, and of America's Indian "wars," 114 years ago.

Needless to say, this event had a tragic effect on all the Lakota people. The majority of those killed were from Si Tanka's band of Cheyenne River Lakota. He was a Minnicoujou but other Cheyenne River bands were also present. Hunkpapas and Yanktonais were also involved, as were some Oglala who were visiting friends or relatives. The church in this picture is not the one built at the Wounded Knee cemetery after the massacre, but is the Pine Ridge church, used as a makeshift hospital for the wounded, some of whom died later. This church was moved to the country north of Loneman School. (Photograph courtesy of Donovin Sprague, taken in 2002.)

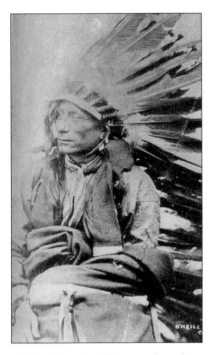

**SHORT BULL "TATANKA PTECELA" (SICANGU), UNDATED.** This photo by the O'Neil Photo Co. of O'Neil, Nebraska shows Short Bull, born in 1845 and a medicine man and one of the principal leaders of the Ghost Dance religion among the Lakota. Short Bull was with Lip's band, and also had been in the Powder River country with leaders such as Black Twin, Red Cloud, Crazy Horse, and Hump prior to his surrender where he participated in the 1860 and 1870 wars, and then lived on Pass Creek. At Pass Creek he had Ghost Dance followers among all of the Lakota but most of them were Oglala and Sicangu. When the new reservation boundary line was drawn in the Wanblee area, his homeland was changed from Pine Ridge Reservation to Rosebud Reservation. In 1890, he led his Ghost Dance followers and some of them joined Si Tanka (Big Foot) in the Badlands. After the December 29, 1890 Wounded Knee Massacre of Si Tanka (Big Foot) and his followers, Short Bull witnessed his followers lying dead in the snow with their "protective" Ghost Dance shirts penetrated by the soldiers bullets. On January 16, 1891, Short Bull surrendered to General Nelson Miles and was sent to Fort Sheridan, Illinois, where he was placed in confinement because of the Ghost Dance. Survivors of the Wounded Knee Massacre were also sent to prison at this location. William F. Cody then got the idea to have the prisoners removed and he recruited them for the Buffalo Bill "Wild West Show." Short Bull traveled to Europe with this group. He attended Washington D.C. delegations and lived until the age of about 70; he journeyed to the spirit world in 1915. Tom Shortbull, President of Oglala Lakota College is a direct descendant of Short Bull and Red Cloud. (Postcard courtesy of Donovin Sprague.)

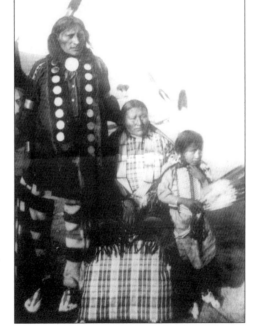

**WEASEL BEAR FAMILY (OGLALA).** This is a picture taken by James Mooney in 1893 of Weasel Bear and his family. The family is also related to Si Tanka (Big Foot) and affiliated by blood to the Cheyenne River bands. This family was involved in the Wounded Knee Massacre of 1890. The Lakota name for Weasel Bear is associated with wolverine bear. (Photograph courtesy of Bureau of Ethnology, Smithsonian.)

**HORN CLOUD "MAHPIYA HE" (MINNICOUJOU) UNDATED.** Several members of the Horn Cloud family were killed in the Wounded Knee Massacre. The Horn Cloud survivors were Dewey Beard/Iron Hail/Dewey Horn Cloud, Joseph Horn Cloud, Daniel White Lance, Frank Horn Cloud, Earnest Horn Cloud, Alice Horn Cloud, and nephews Frank and Ernest. Alice was born at Cheyenne River Agency in 1873, the daughter of Horn Cloud and Good Nest (Holy Nest). She was 17 years old at the time of the massacre, and as it began, her brother Dewey told her to run. She began to run away, accompanied by her nephews, Frank and Ernest. Alice went west and caught a horse, and the three raced to the Stronghold area in the Badlands. During their flight, Alice was shot in both legs and in the back. Survivors who went to the Stronghold were later taken to Pine Ridge for care, where the present IHS hospital is located. Alice thought they were the only survivors but then found her brothers Joseph, Dewey, and Daniel White Lance at Pine Ridge. All the brothers were also wounded and then Alice learned that both of her parents and other relatives were killed. The family came from the northern Lakota and settled at Pine Ridge Reservation following the killing of Chief Sitting Bull at Standing Rock. The Horn Cloud family belonged to the tiospaye (extended family) of Spotted Elk who became known as Chief Big Foot (Si Tanka). Those who were killed are all buried in the mass grave at Wounded Knee cemetery. Alice Horn Cloud later married John White Wolf "Sungmanitu Ska" and they lived at Mission Flat, north of Pine Ridge. They had four children: Peter (died in infancy), Rose (also known as Jessie Cedar Face), Charles, and Susie Waters-Red Bear. John White Wolf toured with Buffalo Bill's Wild West Show and traveled to England twice. Alice lived until 1975. (Photograph courtesy of Oglala Lakota College Archives/Bureau of Ethnology/Musée de l'Homme, Paris, France.)

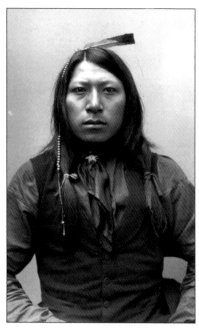

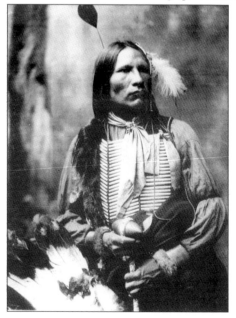

**THOMAS NO WATER "MINI WANICA" (HUNKPAPA/OGLALA).** This photo is undated but is possibly by Heyn and Matzen, c. 1899. (Photograph courtesy of Oglala Lakota College Archives and Bureau of Ethnology, Smithsonian).

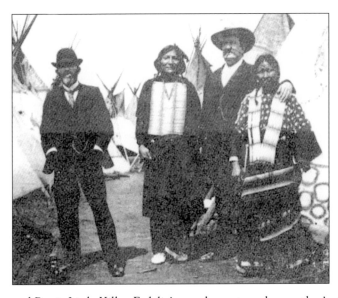

**NO NECK (HUNKPAPA) AND HIS WIFE (OGLALA) AND TWO UNIDENTIFIED NON-INDIANS, UNDATED.** No Neck is often listed as an Oglala. He was Hunkpapa and married into the Oglala. The family is on the 1877 surrender list with Crazy Horse's band at Fort Robinson. When they arrived at Standing Rock they had been living in Canada with groups such as Sitting Bull. The author visited with Fedelia Cross whose mother is Louise Blacksmith and whose father is Robert No Neck. Fedelia's grandparents on her father's side are Guy No Neck and Bessie Little Killer. Fedelia's grandparents on her mother's side are John Blacksmith and Edna Loafer Joe. The Blacksmiths are Minnicoujou Lakota. Fedelia stated that Guy No Neck would definitely consider himself Hunkpapa. The later family would be Hunkpapa/Oglala/Minnicoujou. The No Neck family still has tribal land interests at Standing Rock but became enrolled at Pine Ridge. Smoke family descendants say No Neck was a son of Chief Smoke and brother of Ulala. They believe that No Neck had no children but adopted a child whose family was killed in the 1890 Wounded Knee Massacre. They used the name No Neck, and all the present day family members that go by the name No Neck are descended from the adopted child, not the old No Neck who was Hunkpapa. They stated that one of No Neck's brothers was American Horse, also known as Iron Plume (Minnicoujou), who was killed at the Battle of Slim Buttes in northwest South Dakota. The present American Horse family at Pine Ridge are Oglala, and not related to the American Horse killed at Slim Buttes. No Neck also referred to his sister as Zoe LaBuff Amiotte's mother, called Good Woman, also known as Walks With White. From these records, No Neck, Woman Dress, Spotted Bear (the elder), and Breath Wind (wife of Jules Shangreau) were all half brothers of Walks With White, and all children of Smoke. (Photograph courtesy of Bureau of Ethology.)

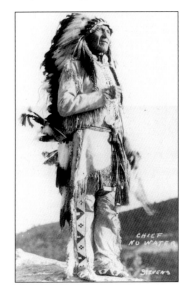

**CHIEF NO WATER "MINI WANICA" (HUNKPAPA).** The No Water name evolved to Star Comes Out, Star, and Starr. When No Water settled on the reservation he was leader of the Ghost Dance religion and many of his followers danced and camped in the Red Shirt Table area. The author has also seen their name on census rolls as Star Comes Along, which is probably a translation variance. This photo by Stevens is undated. (Photograph courtesy of Donovin Sprague.)

*Five*

# WAZI BLO OWAKPAMNI
## (Pine Ridge Agency)

*When the Oglalas were moved from Red Cloud Agency to Pine Ridge Agency, bands were still intact and families received their land allotments. The bands that were formerly scattered throughout the Plains were now confined to the boundaries of the reservation and these bands evolved into communities. The people were now dependent on government food and supply rations, and the reservation was divided into seven districts which then became reservation towns. Pine Ridge Agency became the headquarters for the whole reservation and was known as "Wakpamni" Distribution (town). The other six districts were: White Clay, Wounded Knee, Porcupine, Medicine Root, Eagle Nest, and Pass Creek.*

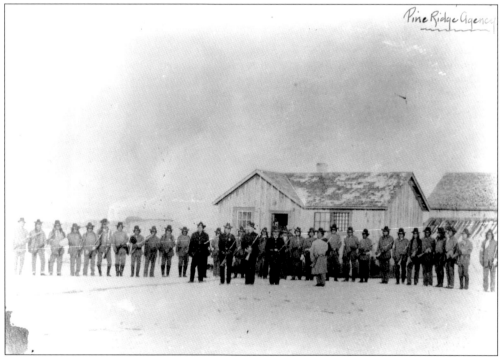

**PINE RIDGE AGENCY.** Photo taken in 1879. The photographer was not recorderd. Lakota policemen are pictured in this early Pine Ridge photo. (Photograph courtesy of Bureau of Ethnology.)

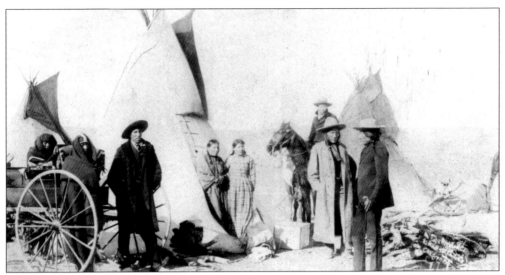

**CHIEF FAST THUNDER "WAKIYAN LUZAHAN" (OGLALA) AND UNIDENTIFIED GROUP.** This undated photo was taken in Chadron, Nebraska. This picture is believed to be from the Pine Ridge area and was developed by a Chadron studio. Fast Thunder is on the far right. (Photograph courtesy of Oglala Lakota College Archives and Bureau of Ethnology.)

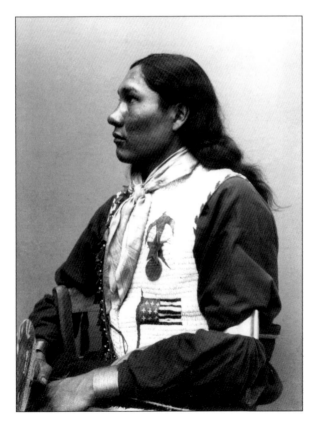

**UNIDENTIFIED LAKOTA, UNDATED.** This picture is from Pine Ridge Reservation. (Photograph courtesy of Oglala Lakota College Archives and Musée d l'Homme, Paris, France and Bureau of Ethnology.)

**RUNNING HAWK (OGLALA), UNDATED.**
Running Hawk was a Lakota Policeman and resided at White Clay, Nebraska. (Photograph courtesy of Oglala Lakota Archives and Musée d l'Homme and Bureau of Ethnology.)

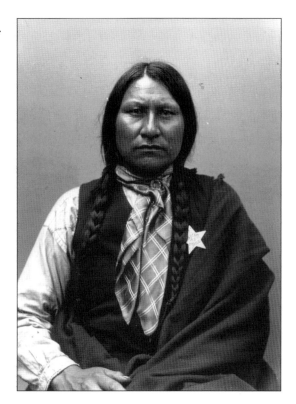

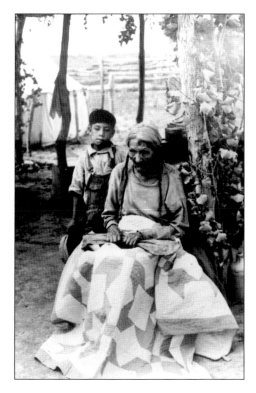

**HE DOG "SUNKA BLOKA" (OGLALA).** This photo was taken at the home of He Dog, shortly before he passed away in 1936. He Dog's son is Reverend Joseph Eagle Hawk. The boy in the picture is unidentified, possibly his grandson. (Photograph courtesy of Mrs. Samuel Eagle Hawk and Leland Case Library, Black Hills State University.)

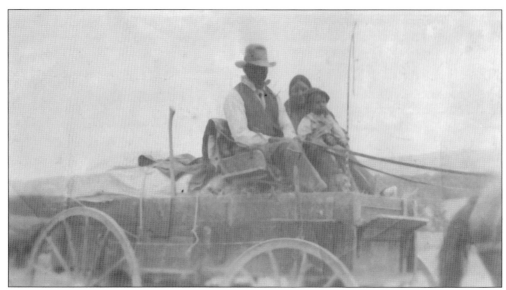

**JACKSON HE CROW, WINOLA CHASE IN WINTER, AND GRANDSON, (MINNICOUJOU/OGLALA), UNDATED.** Jackson and Winola are on their way to Chadron, Nebraska with their team of horses and wagon. Their grandson, whom Winola is holding, is either Hermis or Francis. The parents of Jackson were He Crow "Kangi Bloka" and Louise Afraid Of Bull. He Crow "Kangi Bloka" was killed in the Wounded Knee Massacre on December 29, 1890. His wife Louise survived the massacre but was wounded. A brother of this younger He Crow was Little Crow. Little Crow was also a survivor of the Wounded Knee Massacre and returned to live at Cherry Creek, South Dakota on the Cheyenne River Reservation. (Photograph courtesy of Francis and Michael He Crow.)

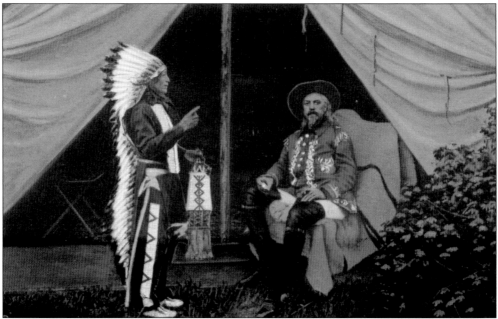

**CHIEF IRON TAIL "SINTE MAZA" (OGLALA) AND BUFFALO BILL CODY, c. 1890.** Iron Tail was a noted leader and performed in the Wild West Show of William F. "Buffalo Bill" Cody. (Original postcard courtesy of Donovin Sprague.)

**JESSIE BLACK HORSE "SUNKAWAKAN SAPA"(LAKOTA), UNDATED.** This photo was taken by the Stevens Studio of Hot Springs, South Dakota. This photo does not specify the identity of everyone. (Photograph courtesy of Oglala Lakota College Archives and Chandler Institute.)

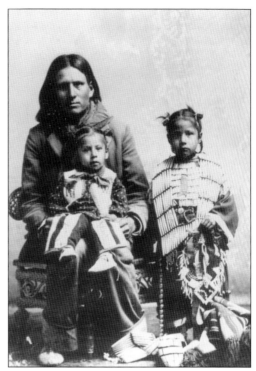

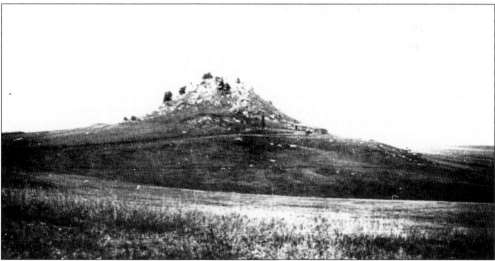

**PORCUPINE BUTTE, UNDATED.** This is a prominent butte between Wounded Knee and Porcupine, South Dakota. One side of the butte looks like a porcupine tail and it was originally known as "porcupine tail." It is the highest point in the area and today KILI-FM radio is housed on the side of the butte where a house is visible in this picture. A 100,000-watt radio tower was later built atop the butte. The author was general manager of this Lakota-owned and -operated radio station for one year and still networks with them. The Si Tanka (Big Foot) Trail passes by the butte and was used by the people in the Wounded Knee Massacre when they arrived from Cheyenne River and Standing Rock. The massacre site is just southwest of this butte. Many of the O'dell Collection photos were from 1930-1940. (Photograph courtesy of Thomas O'dell Collection, E.Y. Berry Library Learning Center, Black Hills State University.)

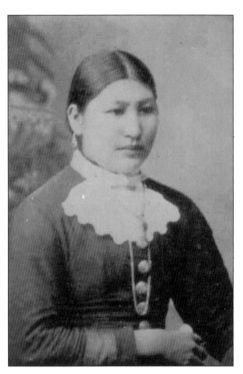

VICTORIA STANDING BEAR-CONROY (SICANGU). This photo was taken *c.* 1893. Victoria was the daughter of George Standing Bear and Lena One Horse/Roaming Nation. She was born in 1866 and married Frank Conroy about 1891. This photo could be dated about the time they were married. Victoria's grandparents were One Horse (b. 1846) and Tunkanawin/Big Woman (b. 1815). The author visited with Marie Yellow Bird Lange in 2002; Marie is the granddaughter of Victoria and Frank Conroy. (Photograph courtesy of Crazy Horse Memorial Foundation and Luther Standing Bear Collection.)

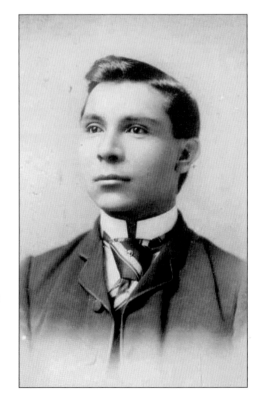

FRANK CONROY (OGLALA), C. 1893. Frank Conroy was born in 1865 and married Victoria Standing Bear. This photo could have been taken about the time they were married. This family has ties to Pine Ridge Reservation and Rosebud Reservation. (Photograph courtesy of Crazy Horse Memorial Foundation and Luther Standing Bear Collection.)

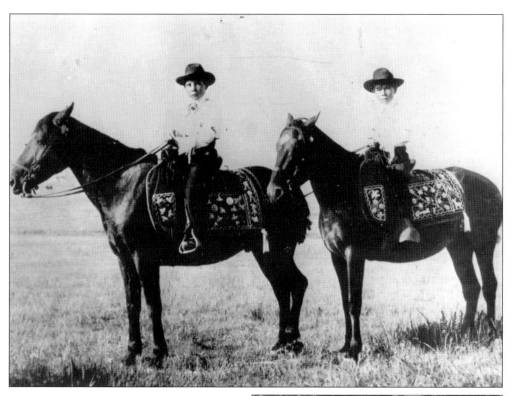

**HARRY CONROY (AT LEFT) AND WALTER CONROY (OGLALA/SICANGU).** Harry and Walter were sons of Frank and Victoria Standing Bear-Conroy. Harry was born in 1894, and Walter was born in 1897. Harry's first wife was Fire Thunder and after she died, he married Hazel. (Photograph courtesy of Crazy Horse Memorial Foundation and Luther Standing Bear Collection.)

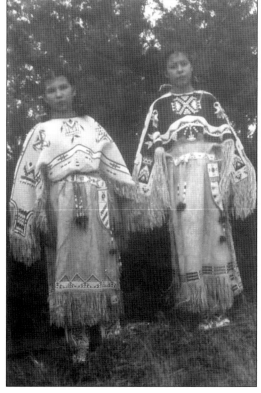

**JULIE CONROY (AT LEFT) AND LILA CONROY (OGLALA/SICANGU), UNDATED.** Julie (Julia) and Lila were the daughters of Frank Conroy and Victoria Standing Bear-Conroy. Julia Conroy was born in 1892. (Photograph courtesy of Crazy Horse Memorial Foundation and Luther Standing Bear Collection).

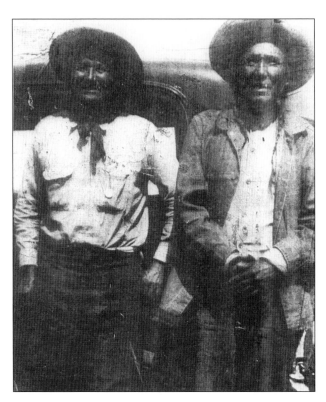

**CHARLES HORN CHIPPS (LEFT) AND JAMES MOVES CAMP (OGLALA), UNDATED.** Charles and James were brothers but James was given the name Moves Camp at the agency by mistake. They are from a prominent family of medicine men. (Photograph courtesy of Chipps family and Bureau of Ethnology.)

**ELLIS CHIPPS (OGLALA), UNDATED.** Ellis Chipps was the great grandson of "Old Man" Chipps/Encouraging Bear. Ellis and his wife Victoria have three children: Charles Chipps, Phillip Chipps, and Godrey Chipps. These three brothers are the fourth generation of Lakota medicine men. The Chipps family is from the Wanblee, South Dakota area. On April 26, 1990 the Oglala Sioux Tribe passed a "Resolution Commemorating The Death Of Ellis Horn Chips." Ellis was recognized for "contributions as former Councilman during the Johnson Holy Rock administration (1960-1962) and for his composition of the Sioux National Anthem. (Resolution No. 90-55XB signed by Oglala Sioux Tribal President Harold Salway and Secretary Theresa Two Bulls). (Photograph courtesy of Chipps family.)

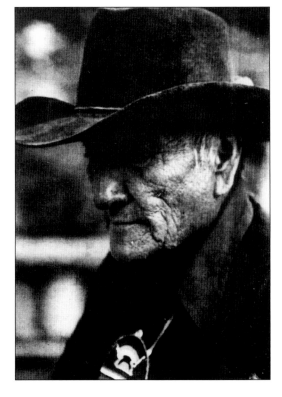

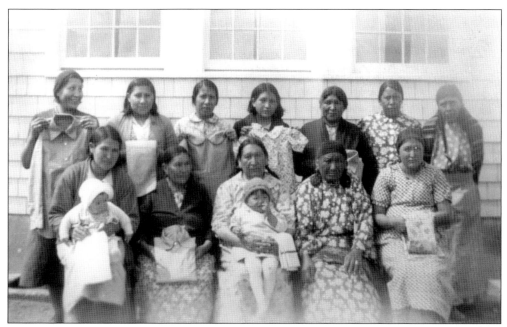

**MANDERSON SEWING CLUB.** Pictured from left to right are as follows: (front row) unidentified, Mrs. Pulliam, Mrs. Yellow Bull, Sophia (Runs Against) Big Turnip, and Fannie Little Dog; (back row) Mary Tall, Dora (Brave) Shoulders, Rose Mesteth, Rosa Red Shirt, Sara Brave, Jessie Kills Ree, and Delia Runs Against. (Photograph courtesy of Oglala Lakota College Archives.)

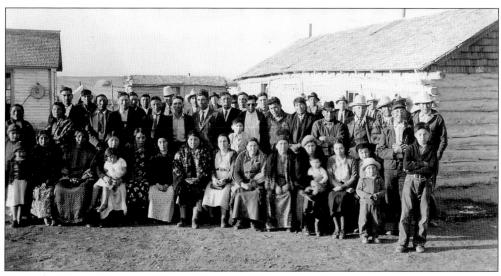

**CHURCH GROUP, OGLALA, SOUTH DAKOTA, UNDATED.** (Photograph courtesy of Red Cloud Indian School and Heritage Center.)

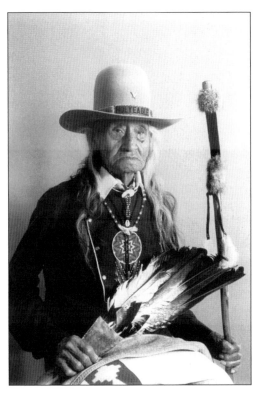

JAMES HOLY EAGLE "WANBLI WAKAN" (OGLALA), C. 1989. James Holy Eagle was born in the spring of 1889 and lived to the age of 102. James went to school at Carlisle Indian School in Pennsylvania with Jim Thorpe. James was a musician and played the coronet. He met Irving Berlin when they served in the U.S. Army. The author presented James Holy Eagle with a Proclamation on his 100th birthday while the author was chairman of the Rapid City Indian/White Relations. James has family ties to Cheyenne River and his children are Oglala/Minnicoujou. (Photograph courtesy of Sonja Holy Eagle family and Catherine Brings The Horses-Silva family.)

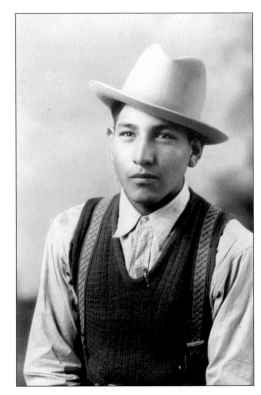

THOMAS NO WATER (HUNKPAPA/OGLALA). This photo was taken Oct. 24, 1934. (Photograph courtesy of Francis and Michael He Crow.)

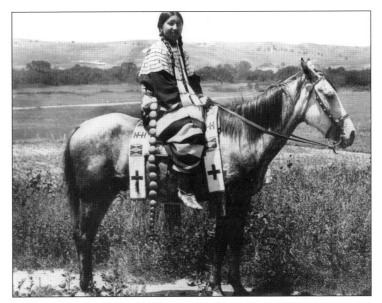

**UNIDENTIFIED WOMAN (OGLALA).** The photographer and date were not recorded for this photo. A young woman poses in traditional dress with her sunka wakan (horse) who has a lazy stitch style beaded saddle blanket. (Photograph courtesy of Oglala Lakota College Archives and Bureau of Ethnology, Smithsonian.)

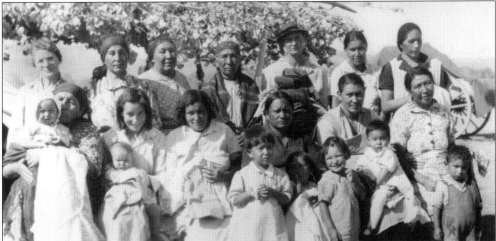

**RED SHIRT TABLE AUXILIARY.** This photo was dated 1903 but was actually taken c.1940. The women's auxiliary from Red Shirt Table are pictured here. The photographer was not recorded. Pictured in the front row, from left to right, are as follows: Mae Red Shirt (the baby that Mae is holding may be Charles Red Shirt Jr.); Tillie Moller-Two Bulls-Poor Thunder (the baby that Tillie is holding may be Mary Rose Steele who is Sarah Steele's child); Sarah Marshall-Steele; Florence Two Bulls-Ten Fingers; the girl standing at front with hands folded may be Florence; Bessie Little Killer-Two Bulls? (the woman behind Florence may be Bessie, Bessie may be holding Christina or Elizabeth Two Bulls?); Margaret Swallow-Dyer (girl in front); Effie Rouilard (woman); Norma Two Bulls-Bad Heart Bull? (baby); Lizzie Two Bulls-Swallow (woman); and Johnny Swallow (boy at far right). Pictured in the back row, from left to right, are as follows: Ethel May Marley; Jennie Marshall-Two Bulls; Lucy Two Bulls-Good Soldier; Alice Two Bulls (Alice's Lakota name was Plenty Horses); John Swallow Sr.; Emily Janis-Two Bulls; Goldie Two Bulls (Goldie's maiden name may have been Conquering Bear); and Lizzie. Lizzie Two Bulls-Swallow married John Swallow Sr. The boy Johnny Swallow (Jr.) married Susanna White Wolf and they had eight children. Johnny and Susanna still live at Red Shirt Table. (Photograph courtesy of Oglala Lakota Archives.)

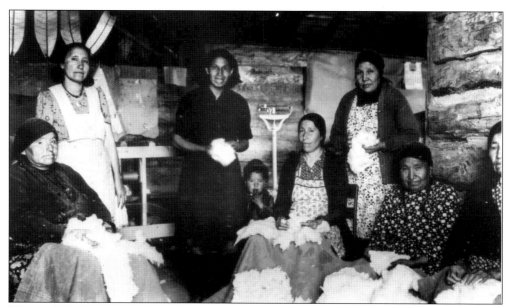

**UNIDENTIFIED PINE RIDGE GROUP.** This picture was taken at a home on Pine Ridge Reservation. (Photograph courtesy of Oglala Lakota College Archives.)

**JACKSON HE CROW (MINNICOUJOU) AND WINOLA CHASE IN WINTER (OGLALA), UNDATED.** Jackson and his wife Winola are shown here at Joe Sleeps' place, near Slim Buttes. Jackson He Crow was a survivor of the Wounded Knee Massacre, which took place when he was 8 years old, and he escaped with no wounds. In 1940, Jackson provided testimony about this event in the book *The Wounded Knee Massacre* (MacGregor). He also gave testimony that appeared in the book *Voices Of Wounded Knee* (Coleman). His parents were He Crow and Louisa Weasel Bear. The parents of Winola were Jacob Chase In Winter and Louisa Black Bear. (Photograph courtesy of Francis and Michael He Crow.)

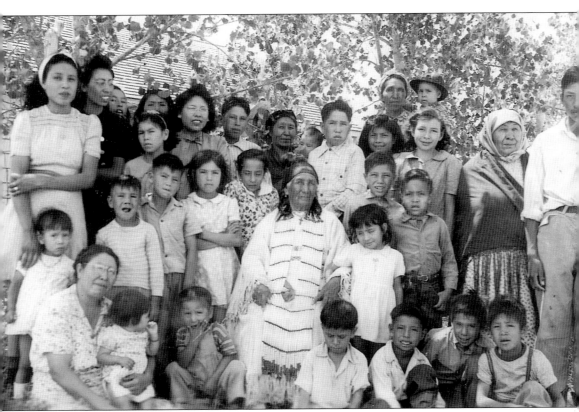

**RED SHIRT TABLE FAMILY GATHERING.** Pictured in this photo taken by Father Zimmerman, c. 1945, are, from left to right: (front row) Lizzie Swallow (holding baby), Norman Two Bulls, Sam Two Bulls, Frank Two Bulls Sr., Eddie "Junior" Two Bulls, and Larry Fast Wolf; (second row) Julie Two Bulls-Garnier, Orville Two Bulls, Lawrence Wayne Two Bulls, Carol Two Bulls-Joy, Ruth Yellow Horse-Cuny, Grandma Alice Two Bulls, Beatrice Swallow-Garreau, Delbert Yellow Horse, and Verdell Yellow Horse; (third row) Lucille Two Bulls-Brown Bull (wearing white dress), Maize Two Bulls-Red Bow (woman in dark dress), Esther Two Bulls-Smith, Vivian Two Bulls-Creathbaum (girl with white head band), Geraldine Two Bulls (behind Vivian), Ramona Two Bulls-Colhoff (woman with eye glasses), Robert "Reverend Bob" Two Bulls, Dora Two Bulls-Fast Wolf (holding baby Todd Fast Wolf), Laverne Two Bulls, Imogene Fast Wolf-Sherman, Delphine Two Bulls-Yellow Horse (holding baby Wilbert "Sonny Boy" Yellow Horse Jr.), Margaret Swallow-Dyer (standing in front of baby Wilbert), Aunt Lucy Two Bulls-Good Soldier, and Jimmy Fast Wolf. This picture was taken in front of Aunt Lucy Two Bull's house at Red Shirt Table. Imogene Fast Wolf-Sherman was also known by her Lakota name, Kills A Hundred. (Photograph courtesy of Ed Two Bulls Jr.)

**WILLIE CHARGE IN THE ENEMY (LAKOTA), UNDATED.** Willie is a relative of Winola (Chase In Winter) He Crow. (Photograph courtesy of Francis and Michael He Crow.)

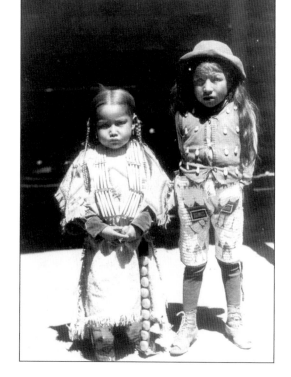

**TWO UNIDENTIFIED CHILDREN.** Photo undated. These children are ready for the powwow. The picture is believed to have been taken on Pine Ridge Reservation. (Photograph courtesy of Oglala Lakota College Archives and Bureau of Ethnology.)

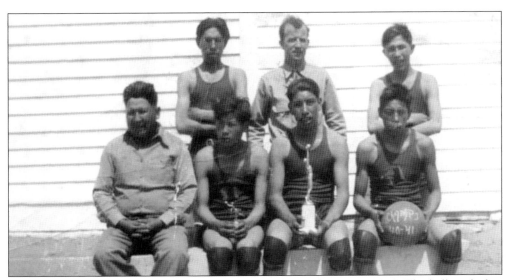

**1941-42 LONEMAN SCHOOL BASKETBALL TEAM.** Photo taken 1941-1942. The ball reads that they were "Basketball Champs." Pictured, from left to right, are: (front row) Eugene Wounded Horse (Coach), Richard Marrowbone, Tibbits Eagle Hawk, and Narcisse Sharpfish; (back row) Charles Holy Pipe, R.J. Smith, (principal), and Chris Jumping Bull. (Photograph courtesy of Francis and Michael He Crow.)

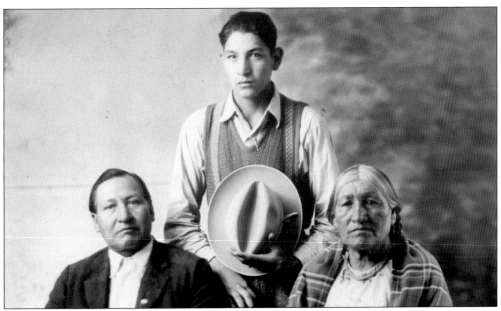

**EUGENE NO WATER (HUNKPAPA), LOUISA SWORD NO WATER (OGLALA), AND (STANDING) THOMAS NO WATER (HUNKPAPA/OGLALA), OCTOBER 24, 1934.** Eugene No Water married Louisa Sword, and their son Thomas is pictured holding his hat. In the Pine Ridge Census Roll of 1886, a 52-year-old No Water was listed as father, his wife Black Crow might have been 45, and their sons were recorded as Rising Star, age 12, and Winter, age 8. The elder No Water in this census would have been born about 1844, and is likely the same one who was married to Black Buffalo Woman. Black Buffalo Woman was said to be a daughter of Chief Red Cloud's brother. (Photograph courtesy of Francis and Michael He Crow.)

HIGH CRANE "HOKA WANKAL"(LAKOTA),
UNDATED. High Crane was a relative of Winola
(Chase In Winter) He Crow. (Photograph
courtesy of Francis and Michael He Crow.)

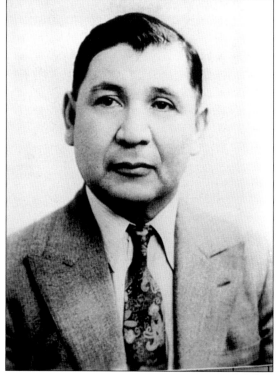

HARRY CONROY (LAKOTA), UNDATED.
Harry Conroy was born in 1894 and
his parents were Frank and Victoria
Conroy. Harry served as vice-president
of the Oglala Sioux Tribe in 1936 and
in 1950-1952. He had served other
functions in tribal government service
as well. (Photograph courtesy of Oglala
Lakota College Archives.)

**FRANCIS HE CROW (MINNICOUJOU), UNDATED.** The parents of Francis He Crow were Moses He Crow and Eva Pumpkin Seed. The grandparents of Francis were Jackson He Crow and Winola Chase In Winter. The parents of Jackson He Crow were He Crow and Louisa Weasel Bear. The parents of Winola Chase In Winter were Jacob Chase In Winter and Louisa Black Bear. The generation before He Crow is Si Tanka (Big Foot) and his wife Sinte Cikala (Small Tail), and on Louisa Weasel Bear's side of the family, the lineage goes back to her father Kills White Man and her mother Good Elk. The parents of Louisa Black Bear were Mato Sapa and his wife Iron Horse. According to the He Crow family, the father of One Horn/Lone Horn was Chief Red Fish. This differs from many of the One Horn/Lone Horn descendants at Cheyenne River who list Black Buffalo as the father of One Horn/Lone Horn. Francis and his wife Lema (Case) He Crow have seven children: Gregory, Joanne, Loracita, Lucinda Ann, Lupita Charity, Michael, and Viola Faith. (Photograph courtesy of Francis and Michael He Crow.)

**AMOS RED PAINT (OGLALA), UNDATED.** Amos Red Paint lived north of Loneman School. Due to a mix up at the agency his two brothers received different names and became known as Red Bow and Broken Nose. (Photograph courtesy of Francis and Michael He Crow.)

FRANK AFRAID OF HORSE (LAKOTA), UNIDENTIFIED WOMAN, HENRY CLOUD SHIELD (LAKOTA), UNDATED. (Photograph courtesy of Francis and Michael He Crow.)

HERMIS HE CROW (MINNICOUJOU), UNDATED. Hermis is pictured here on his horse whose name is Hinze Tanka (Big Buckskin). (Photograph courtesy of Francis and Michael He Crow.)

**ROBERT HE CROW (MINNICOUJOU), SEPTEMBER 5, 1938.** Robert is the brother of Moses He Crow, and their parents are Jackson He Crow and Winola Chase In Winter. An early He Crow ancestor appeared in an 1844 winter count (calendar). The name He Crow was interpreted as Male Raven and it was recorded that 30 Minnicoujou were killed. He Crow/Male Raven was the leader of a war party. He sent 3 scouts out and they met a lone Shoshone whom they killed and scalped, but they let his son go. The scouts returned to tell of their success and He Crow set out to meet the enemy. He Crow took 30 Oglalas on foot but the Shoshone boy had returned home and spread the alarm. Hundreds of Shoshone came on horseback in a snowstorm. He Crow and his 29 men were killed. One survivor, named Runs Noisy, shot a Shoshone off his horse and got away on the horse. He returned home and the other part of this band was known as the Orphans band. (Photograph courtesy of Francis and Michael He Crow.)

**CORA PUMPKIN SEED (OGLALA).** Cora is from Porcupine, South Dakota. (Photograph courtesy of Francis and Michael He Crow.)

**ARCHIE SWORD AND BROTHERS (OGLALA).** This photo was taken by Rise Studio, May 17, 1923. Archie Sword is pictured in the front with the cowboy hat, along with his brothers who are unidentified. Archie was born in 1916 and died on Jan. 26, 1926 at the age of 10. His father's name was Sword. (Photograph courtesy of Francis and Michael He Crow.)

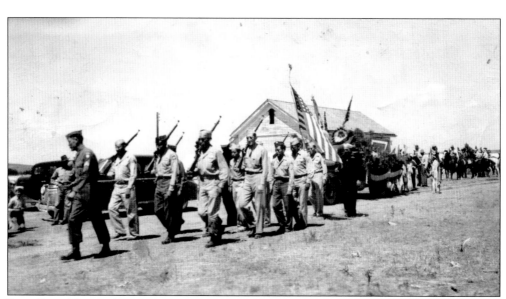

**LEVI FAST HORSE AND WORLD WAR II VETERANS, (OGLALA), AUGUST 1945.** Levi Fast Horse is on the far left leading this group of 1945 World War II veterans at White Clay, Nebraska. Levi was born on June 6, 1916, and lived to the age of 55, when he passed away in 1971. (Photograph courtesy of Francis and Michael He Crow.)

**MOSES HE CROW (MINNICOUJOU) AND JERRY AMIOTTE (OGLALA).** Photo taken June 1959. Moses is pictured here with his grandson Jerry, who is the son of Vivian He Crow-Red Shirt. Moses He Crow married Eva Pumpkin Seed and their children were Francis (married Lema Tulane-Case), Lawrence, Abraham, Cecelia (married Richard Broken Nose), Vivian (married Clyde Redshirt), and Norma. Moses was born in 1906 and lived to the age of 82 when he passed away in 1989. (Photograph courtesy of Francis and Michael He Crow.)

**LEONARD HE CROW (MINNICOUJOU/ OGLALA?), SEPTEMBER 6, 1936.** Leonard is a very young man here, posed in his wagon (modern travois). (Photograph courtesy of Francis and Michael He Crow.)

**HENRY CLOUD SHIELD (LAKOTA), UNDATED.** Grandpa Henry is getting a haircut while his sunka waits his turn. (Photograph courtesy of Francis and Michael He Crow.)

**MR. HE CROW AND CHILD, UNDATED.** (Photograph courtesy of Francis and Michael He Crow.)

JOHN ANDREW RANDALL (OGLALA). This photo was taken in the 1920s. John was kicked in the mouth by a horse. He later died in 1931 in a fire. His wife was Alice Garreau-Hunter and they raised race horses. (Photograph courtesy of Alvera Wize.)

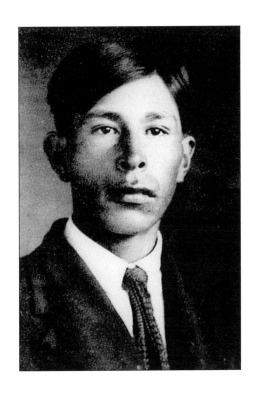

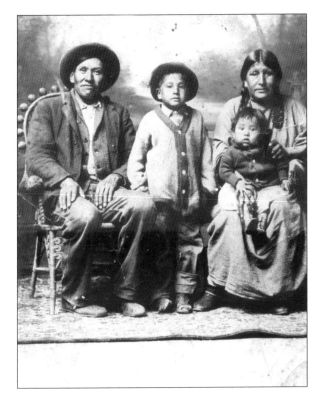

MR. LEFT HAND, MRS. LEFT HAND, ANDREW LEFT HAND, AND UNIDENTIFED HOKSICALA (BABY), (OGLALA), UNDATED. This photo is from the Lone Bear family. Andrew Left Hand was born November 27, 1898 and lived to the age of 87 when he passed away in December of 1985. (Photograph courtesy of Carmen Yellow Horse.)

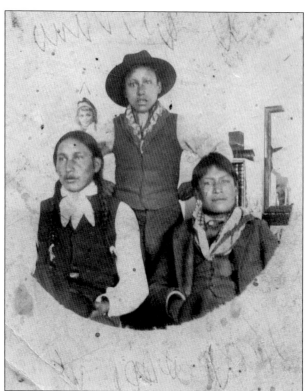

WHITE BEAR CLAWS AND TWO UNIDENTIFIED HOKSILAS (LAKOTA), UNDATED. The back of the picture reads, "White Bear Claws," with the first name possibly James, but it is not specified which figure is identified. The writing on the front is also partially worn off and reads, "Jacob...Cheyn. River, S.D." James White Bear Claw was born in 1885 and lived until 1942. His father was also known as White Bear Claw. The White Bear Claws family settled at Arrow Wound Table at Red Shirt. (Photograph courtesy of Carmen Yellow Horse.)

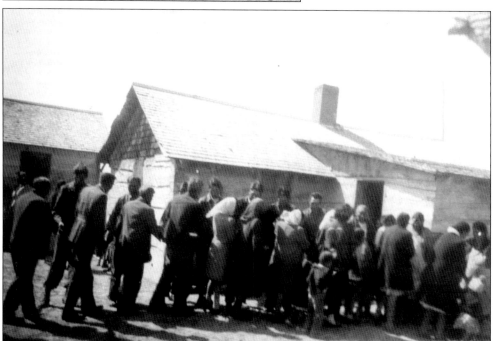

JEFF HE CROW (MINNICOUJOU/OGLALA?), MAY 1948. In this picture, Private Jeff He Crow is home on furlough from military service and the people are greeting him. (Photograph courtesy of Francis and Michael He Crow.)

**AMBROSE BELT (OGLALA).** Photo taken in 1948. Ambrose was a veteran of the U.S. Navy and worked as a rancher at Pine Ridge Reservation. He was 26 years old when this photo was taken. Ambrose married Elizabeth Two Bulls. Reverend Bob Two Bulls was Ambrose's brother-in-law. Ambrose was born in 1922 and passed away in 1996, close to the age of 74. (Photograph courtesy of Holiday Magazine and Donovin Sprague.)

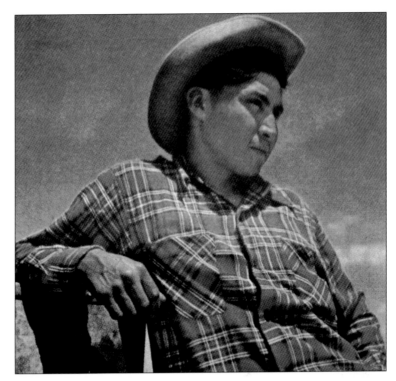

**ANDREW STANDING SOLDIER (OGLALA), ARTWORK. POSTCARD BY C.E. ENGLE, 1949.** This artwork was taken from an original oil painting by noted artist Andrew Standing Soldier. Andrew's art captured the early reservation period. This shows a Lakota family traveling, using a team of horses and a wagon. Andrew was born in 1917 and lived in Hisle, S.D. His parents were Joseph "Elk" Standing Soldier, who was a Lakota scout and policeman, and Julia Fast Horse. Andrew later moved to Gordon, Nebraska and his wife Lema died early. His children include Andrew Jr., Ted, Victor, Edward, and Steve. His unique artwork was largely unrecognized during his lifetime. (Postcard courtesy of Donovin Sprague.)

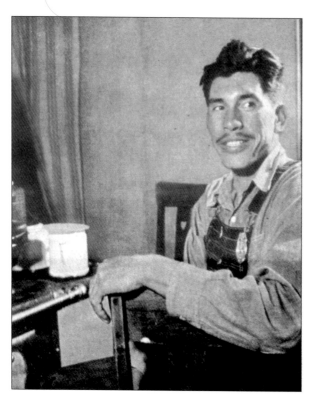

JOE SWIFT BIRD "ZINTKALA LUZAHAN"(OGLALA), 1948. Joe Swift Bird was 26 years old when this photo was taken. He served in the U.S. Air Force and was a town policeman. (Photograph courtesy of Holiday Magazine and Donovin Sprague.)

RICHARD AND CORA GOOD SOLDIER (OGLALA), 1948. Richard Good Soldier married Cora about 1891. Cora was born in 1873, and she was 75 years old when this photo was taken. (Photograph courtesy of Holiday Magazine and Donovin Sprague.)

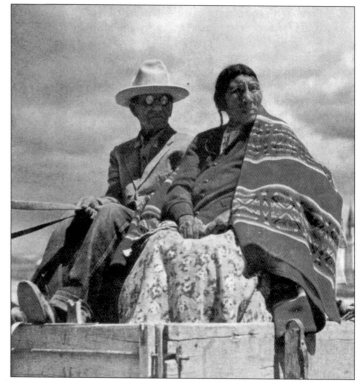

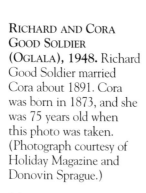

**CHARLES KILLS THE ENEMY (OGLALA), 1948.** Records indicate that Charles Kills Enemy married Rosa Kills Enemy about 1892. Rosa was born in 1869. Another Charles Kills Enemy was younger than this man and might have been his son. Kills Enemy is also a Sicangu name. (Photograph courtesy of Holiday Magazine and Donovin Sprague.)

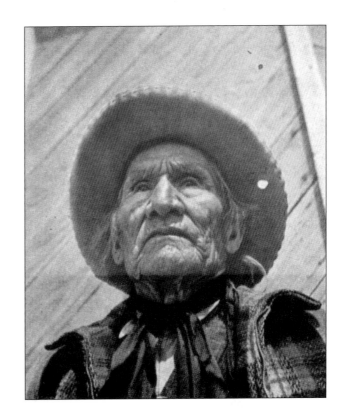

**CATHERINE WISE (BABY) AND ALICE RANDALL (MINNICOUJOU), UNDATED.** Catherine's mother was a jockey who wore her riding pants under her dress. She lived in Wanblee, South Dakota. (Photograph courtesy of Alvera Wise.)

NICHOLAS CRAZY THUNDER (OGLALA) AND JEANETTE RANDALL CRAZY THUNDER (OGLALA/CHEYENNE), 1950. This picture was taken at Pine Ridge boarding school. (Photograph courtesy of Alvera Wise.)

RANDALL FAMILY, PORCUPINE BUTTE. Pictured here, from left to right, are: (back row) Alice Mae Fast Horse Randall and Robert Andrew Fast Horse; (middle row) Catherine Lucille Randall and Vandall William Fast Horse. The children in the front row, not identified in particular order are: Ramona Elsie Randall, Darlene "Sybil" Fast Horse, Cordelia Wilma Randall and Jeanette Frances Randall. This photo was taken before 1935 at Porcupine Butte. The information on this photo reads that the family spent three summers at this house. "Daddy was a special Deputy Officer for the Bureau of Indian Affairss. Bob (Robert) worked in the summer at the look-out tower." (Photograph courtesy of Alvera Wise.)

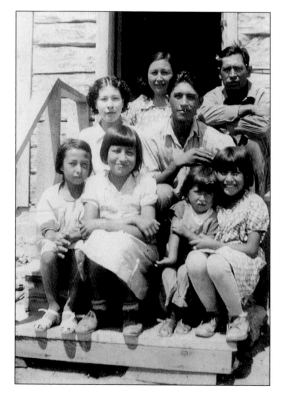

**RANDALL FAMILY, PORCUPINE BUTTE.**
Pictured here, from left to right, are: Ramona
Elsie Randall (Oglala/Cheyenne), Kate
Garreau-Poor Elk-McGras-Hunter-Hall-Blue
Legs (Minnicoujou). This photo was taken
in 1935 at Porcupine Butte. Kate had the
above-married names and her Lakota name
was Kills Plenty. Kate's grandparents were
One Horn/Lone Horn and Wind. Wind and
two of her sisters were among the seven wives
of One Horn/Lone Horn. Kate's parents were
Thunder Buffalo and his wife Four Horses.
A few of the well-known names in Lakota
history included in the One Horn/Lone
Horn genealogy are Rattling Blanket Woman
(biological mother of Chief Crazy Horse),
Chief Crazy Horse, Chief Hump (High Back
Bone), Chief Hump II, Chief Si Tanka (Big
Foot), Touch The Cloud, He Crow, Frog
(Gnaska), and Pipe On Head. (Photograph
courtesy of Alvera Wise.)

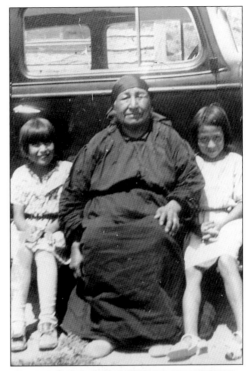

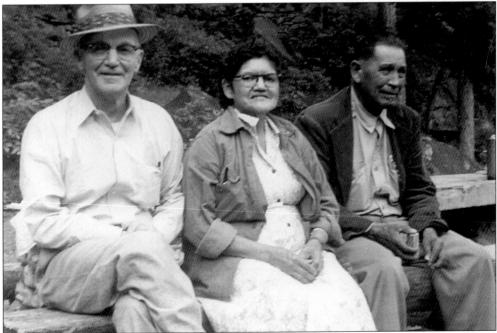

**CLIFFORD JAMES HALL, SOPHIA WABANASSUM BETTELYOUN (MENOMINEE), AND ROBERT
ANDREW FAST HORSE (OGLALA), UNDATED.** This picture was taken at a picnic grounds in
Hot Springs, South Dakota during a family reunion. Clifford was a veteran of World War II, and
is now buried at Mountain View Cemetery in Rapid City, South Dakota. Sophia was a member
of the Menominee Tribe. (Photograph courtesy of Alvera Wise.)

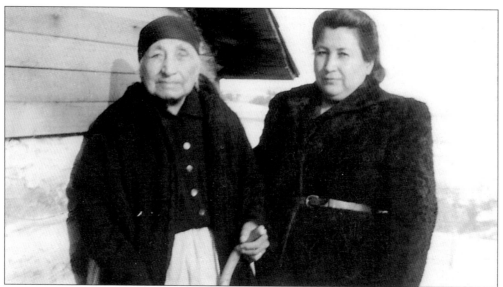

Kills Plenty, also known as Kate Garreau-Hunter-Hall-Blue Legs (Minnicoujou) and Alice Mae Hall-Garreau-Fast Horse (Lakota), Undated. (Photograph courtesy of Alvera Wise.)

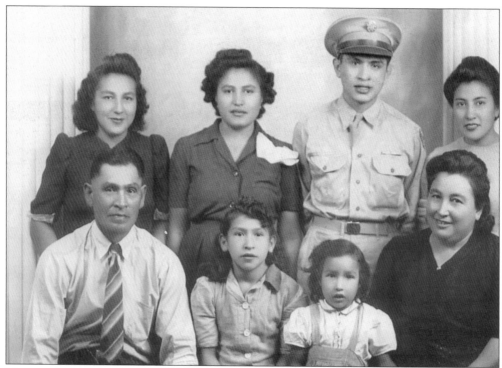

Members of the Fast Horse and Randall Families, 1941. Pictured, from left to right, are: (front row) Robert Andrew Fast Horse, "Sybie" Darlene Fast Horse, Roberta Virginia Fast Horse, and Alice Mae Garreau-Hall-Fast Horse (all are Oglala except Alice Mae who is Minnicoujou); (back row) Jeanette Frances Randall, Cordelia Wilma Randall, Vandall William Fast Horse, and Ramona Elsie Randall (Oglala). (Photograph courtesy of Alvera Wise.)

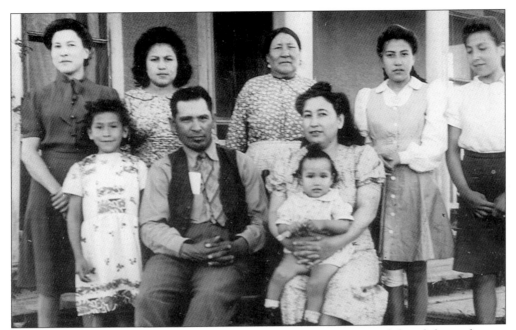

**MEMBERS OF THE FAST HORSE AND RANDALL FAMILIES, 1941.** Pictured, from left to right, are: "Sybie" Fast Horse, Robert Andrew Fast Horse (stepfather), Alice Mae Fast Horse (mother), Roberta Fast Horse (baby); (back row) Jeanette Randall, Ramona Randall, Aunt Jeanette Dark Face, Cordelia Randall, and Catherine Randall. All of the Randalls pictured here are Oglala/Cheyenne. The Fast Horses are Oglala. Jeanette Dark Face (Lakota) married Edward Hunter. Edward Hunter is in the Minnicoujou family tree of One Horn/Lone Horn and his wife, Wind. (Photograph courtesy of Alvera Wise.)

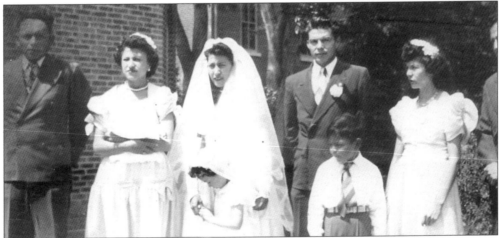

**WEDDING OF WALLY BETTELYOUN (OGLALA) AND RAMONA RANDALL (OGLALA/CHEYENNE).** Pictured, from left to right, are: Odgen Francis Wilson, Cordelia Wilma Randall-Hauff, Ramona Elsie Randall-Bettelyoun, Waldrin "Wally" Jerome Bettelyoun, Ethel Marcie Bettelyoun, Nicholas Crazy Thunder, Alvera Franklin Wise (flower girl), Barry Wilson (ring bearer). Odgen is the brother-in-law of the groom and Nicholas is the brother-in-law of the bride. Ethel is the sister of the groom and Cordelia is the sister of the bride. This picture was taken at Holly Rosary Mission. (Photograph courtesy of Alvera Wise.)

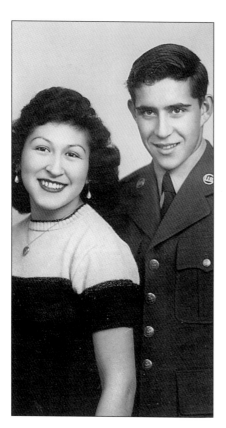

ROBERT WAYNE MCLANE AND SYBIL "DARLENE" FAST HORSE MCLANE (OGLALA), 1951. Bobby and Darlene are pictured here on their wedding day. (Photograph courtesy of Alvera Wise.)

ST. AGNES CHURCH WEDDING, MANDERSON, SOUTH DAKOTA. This photo was taken c. 1945. This photo was recently received and the author is working on identification of the people at this Manderson, South Dakota wedding. Ben Black Elk is standing at the far left and the wedding might be that of Leo Amiotte and Emma Romero. Included in the photo in no particular order are Ben Black Elk, Fannie Yellow Bull, Roy Wooden, Mrs. Chester Wooden, Mrs. Williams, Geraldine Pourier and John Lone Goose. Roy Wooden is the son of Mrs. Chester Wooden, and it was recalled that Mrs. Williams took care of St. Agnes Church. (Photograph courtesy of Red Cloud Indian School and Heritage Center.)

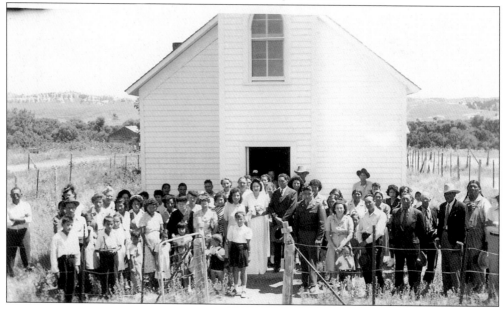

**WILLIAM SPOTTED CROW "KANGI GLESKA"(OGLALA), 1948.** Chief William Spotted Crow was born in 1870 and lived until 1956. Goldie Little Crow of Allen, South Dakota has said that her son Aaron Running Hawk was a great-great grandson of Chief Spotted Crow on his father's side. William Spotted Crow is buried in the Episcopal Cemetery south of the city of Pine Ridge. (Photograph courtesy of Holiday Magazine and Donovin Sprague.)

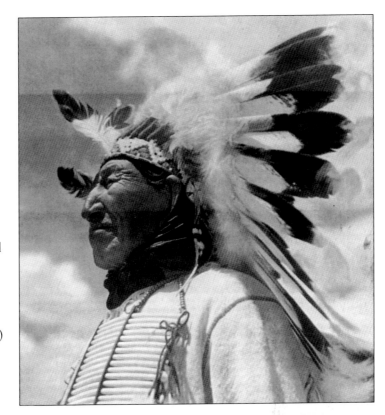

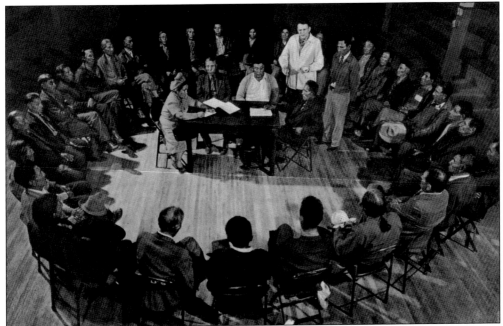

**TREATY COUNCIL, 1948.** Pine Ridge Reservation Agent C.H. Powers is the non-Indian standing to the right, addressing the tribal council members. The woman seated at the table is the recording secretary. (Photograph courtesy of Holiday Magazine and Donovin Sprague.)

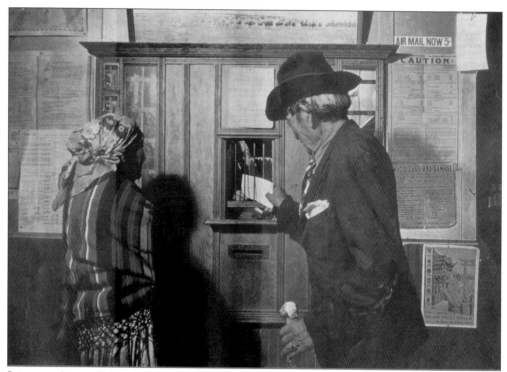

JOE AND AGNES EAGLE HAWK (OGLALA), 1948. Joe and his wife Agnes are pictured here at the Oglala Post Office picking up their mail. Agnes was 74 years old at this time. (Photograph courtesy of Holiday Magazine and Donovin Sprague.)

WOUNDED KNEE TRADING POST, 1948. These men have gathered for conversation outside the trading post. The trading post was just south of the 1890 Wounded Knee Massacre site. It was destroyed in 1973 when the American Indian Movement occupied the area, an action which escalated into armed conflict. A church next to the massacre site was also destroyed. Today there are remnants of the church's foundation still present at the site. (Photograph courtesy of Holiday Magazine and Donovin Sprague.)

**HOME OF JOE AND AGNES EAGLE HAWK, 1948.** Pictured, from left to right, are: Tibbits Eagle Hawk, Agnes Eagle Hawk, and Joe Eagle Hawk Family (Oglala). Tibbits Eagle Hawk is visiting his aunt and uncle. They use a wood stove for heating. (Photograph courtesy of Holiday Magazine and Donovin Sprague.)

**MR. AND MRS. AMOS LITTLE AND ALOYSIUS PUMPKIN SEED (OGLALA), 1948.** Amos and his wife are traveling with a team of horses and wagon to visit relatives; their grandson Aloysius leads the way on horseback. (Photograph courtesy of Holiday Magazine and Donovin Sprague.)

105

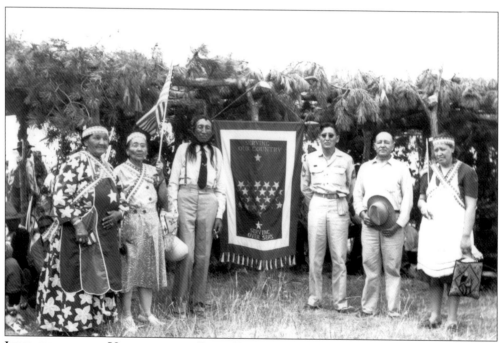

NELLIE "NETTIE" HAIRY BIRD-DEON (OGLALA) AND MARGARET SHANGREAUX-GALLIGO (OGLALA). This photo is undated, but it is probably from the 1920s. Nettie Hairy Bird-Deon is the great grandmother of Cynthia Deon Gonzalez of Rapid City, South Dakota, who provided the photograph. Nellie was born and raised at Pine Ridge Reservation, and this picture was taken at the Holy Rosary Boarding School. Margaret Shangreaux was born in 1912 and lived until 1983. Nettie Hairy Bird was born in 1897 and passed away in 1921 at about age 24. She had a daughter, Marie Deon who was born in 1918. Nettie's mother was Jennie Hairy Bird, who was born in 1876. The children of Jennie were: Rosie Hairy Bird-Brown Eyes (b. 1893, d. prior to 1932); Ernest Hairy Bird (b. 1899, d. 1918); Nellie/Nettie; Jessie Mills (b. 1905); Dora (Prudy) Iron Bear (b. 1907); Samuel H. Hairy Bird (b. 1912); and Leroy Hairy Bird (b. 1916). (Photograph courtesy of Cynthia Deon Gonzalez.)

LEFT TO RIGHT: UNIDENTIFIED, ROSE ECOFFEY (AKA "PRINCESS BLUE WATERS"), CHESTER RED KETTLE (CHAIRMAN 1950-52), WILLIAM SPOTTED CROW, WILLIAM "BILLY" FIRE THUNDER, AND DORA ROOKS? (OGLALA), 1943. The man identified as William Fire Thunder is believed by some to be Pete Cummings. (Photograph courtesy of Oglala Lakota College Archives and Bureau of Ethnology.)

## MABEL BULLMAN LONG SOLDIER (OGLALA)

Photo taken in 2003. Mabel Bullman married Clarence Long Soldier (Oglala/Hunkpapa). Her parents were Daniel Bullman (b. 1879) and Sally White Face. Some of Daniel's relatives include the families of Iron Shell, Spotted Tail, Red Horn, and Crow Dog. Sally White Face was related to the families of American Horse and Red Cloud. The parents of Clarence Long Soldier were Antoine Long Soldier and Elizabeth "Lizzie" Randall. Mabel and Clarence were the parents of Al, Thelma, Edwin Turk, Larry "Sam", Daniel, Richard, Johnny, Harley, Farrell, Germaine, Laura and Amy. Antoine Long Soldier's father was Grey Hawk, a Hunkpapa Lakota. (Photograph courtesy of Donovin Sprague.)

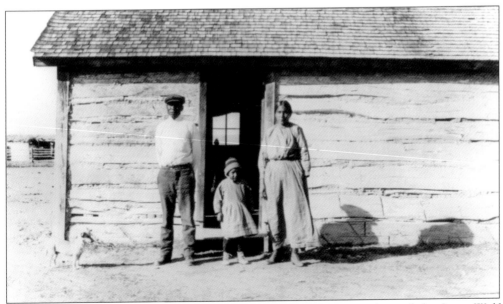

OLIVER LONE WOLF'S FAMILY (OGLALA), UNDATED. Many members of the Lone Wolf family settled in the Pass Creek District of Pine Ridge Reservation. (Photograph courtesy of Oglala Lakota College Archives.)

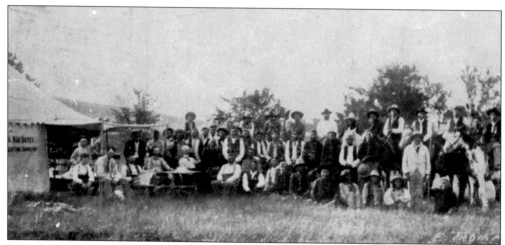

PINE RIDGE INDIAN COUNCIL, UNDATED. This photo, taken by E. Tryman, shows a large group gathered for this council at Pine Ridge. This postcard has a place for a 1-cent stamp. (Postcard courtesy of Carmen Yellow Horse.)

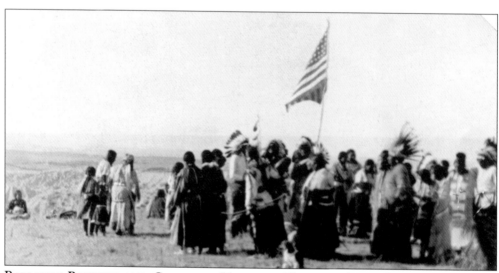

BADLANDS POWWOW AND CEREMONY, UNDATED. This group has gathered at the edge of the Badlands for dance and a ceremony, possibly a July 4th celebration or a veterans/warrior ceremony. (Photograph courtesy of Carmen Yellow Horse.)

*Six*

# OWAYAWA EL' TIPI

## *(Boarding Schools)*

# WOUNSPE TECA

## *(New Education)*

Oglalas attended early boarding schools such as the Hampton Institute in Virginia, which was founded for African Americans. Richard Henry Pratt founded the Carlisle Indian School in Pennsylvania, following the model at Hampton, but exclusively for attendance by American Indians. In September 1879, Pratt recruited in Dakota Territory for Carlisle students. Later, many such boarding schools were established across the United States. Today students can attend Lakota elementary and secondary schools on the reservation and Oglala Lakota College on Pine Ridge Reservation for higher education.

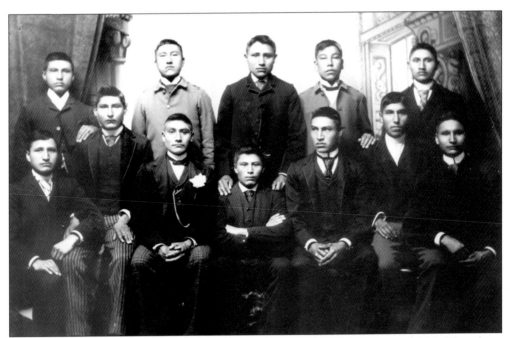

PINE RIDGE STUDENTS AT CARLISLE INDIAN SCHOOL, PENNSYLVANIA, C. 1884. This photo was taken by Choate. Pictured, from left to right, are: (back row) Sam Dion, James One Star, Howard Slow Bull, Charles Brave, Willis Black Bear; (front row): Thomas Black Bear, Alex Man Above, Charlie Smith, Andrew Beard, Herbert Good Boy, Robert Horse, Phillips White. (Photograph courtesy of Cumberland Co. Historical Society, Carlisle, PA.)

109

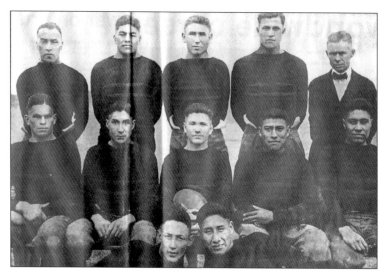

**CARLISLE INDIAN SCHOOL FOOTBALL TEAM, CARLISLE, PENNSYLVANIA, 1917.** Jacob "Jake" Herman (Oglala) is seated in the middle row, on the left. Jake graduated from Carlisle, and afterwards he worked at the naval shipyards in Philadelphia. Later he returned to Pine Ridge Reservation where he and his wife, Alice Janis Herman, raised their four children: Rex Herman, Paul Herman, Faith Herman Lee, and Hope Herman Brewer. Jake's parents were Antoine Herman and Elizabeth Clifford. Jake's grandfather was also named Jacob Herman. Grandfather Jacob was born in Germany and came to the United States in 1844 at the age of 17. He was employed in the army as a blacksmith at Fort Laramie, and later moved to Fort Randall. While he was at Fort Laramie, he married Mary Tesson (White Cloud) from Kansas. He died in an accident with a team of horses at Fort Randall in 1874. According to Rex Herman, one of the players in this photo was still living, at the age of 101 years old. He is from a southern tribe and may know the identity of the others. Rex Herman is now 72 years old. Jake was a well-known rodeo clown, and his rodeo photos could fill a book. He used a mule named Jenny as part of his rodeo act. His Lakota name was Loves To Move Camp. (Photograph courtesy of Rex Herman.)

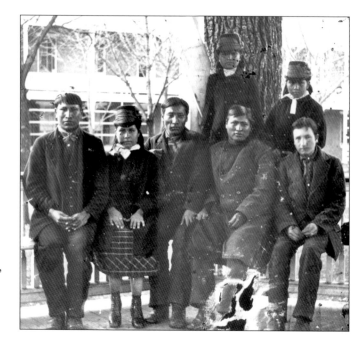

**PINE RIDGE STUDENTS AT CARLISLE INDIAN SCHOOL, PENNSYLVANIA.** This photo was taken by Choate at the Carlisle Indian School in Carlisle, Pennsylvania between 1879-1880. These students are the children of Chief American Horse and Chief High Wolf. The students are not identified in a particular order but the three girls are Daisy Glade, Lucy Day, and Mary Bridgeman. The boys are Bear Don't Scare, Lone Hill, Singer, and Frank Twiss. (Photograph courtesy of Cumberland Co. Historical Society, Carlisle, PA.)

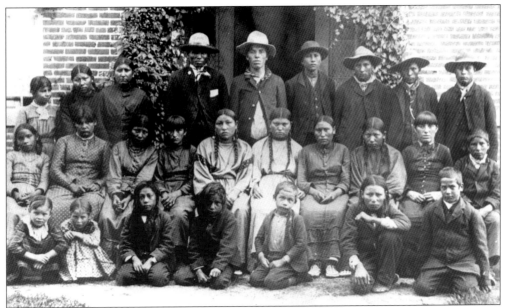

**PINE RIDGE CHILDREN AT CARLISLE INDIAN SCHOOL, PENNSYLVANIA.** This photo was taken by Choate at the Carlisle Indian School in Carlisle, Pennsylvania on August 19, 1887. This picture was taken shortly after these students arrived from Pine Ridge Agency, Dakota Territory. Pictured from left to right are as follows: (front row) Rosanna Rooks, Lizzie Carlow, Nathan Lone Wolf, Buffalo Lone Wolf, George Cottier, Moses Two Bulls, Henry Cottier; (middle row) Emily Lone Wolf, Julia Good Win? Iron?, Lizzie Wolf Soldier, Theresa Bissonette, Rosa Flies, Mable No Flesh, Mary Shoulder, Josephine Wolf Soldier, Lillie Bissonette; (back row) Louise Goulette, Vina Red Horse, Nancy Black Eyes, Samuel Broken Rope, Jackson Bissonette, Oscar Pretty Back, Martin Thunder Hawk, Willis White Wolf, and Elmore Little Chief. (Photograph courtesy of Cumberland Co. Historical Society, Carlisle, PA.)

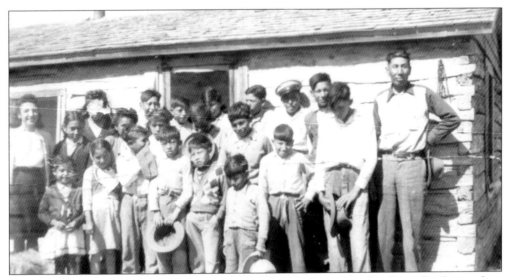

**PRESBYSTERIAN BIBLE SCHOOL, 1948.** The names of some of the He Crow family members are attached to this photo: Cecelia, Vinie?, Abraham, Norman He Crow, and Lawrence. (Photograph courtesy of Francis and Michael He Crow.)

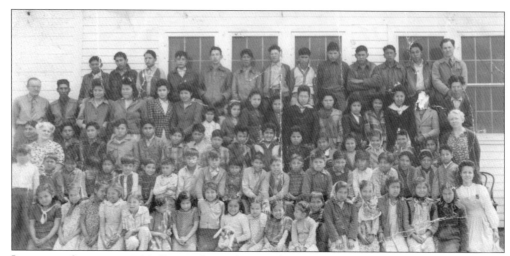

LONEMAN SCHOOL, 1946. Pictured are the 1st through 8th grade classes of the Loneman School. (Photograph courtesy of Francis and Michael He Crow.)

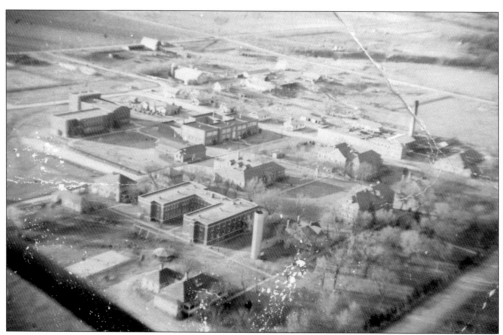

OGLALA COMMUNITY HIGH SCHOOL, UNDATED. This is a picture of the grounds at the old Pine Ridge High School, probably taken during the 1940s. (Photograph courtesy of Francis and Michael He Crow.)

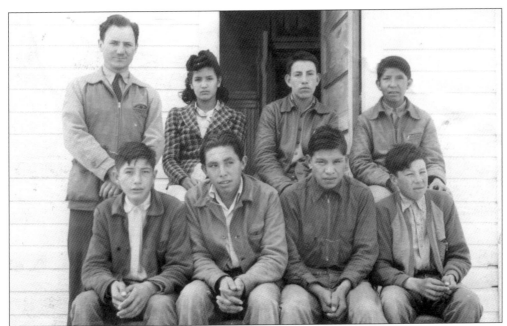

LONEMAN SCHOOL 8TH GRADE CLASS, 1945. Pictured from left to right are as follows: (front row) Melvin Blacksmith, Stanley Looking Elk, Hermis He Crow, and Russell Crow; (back row) George McGregor (principal), Jenny Gillespie, Hoover Running Eagle, and Julius Bad Heart Bull. (Photograph courtesy of Francis and Michael He Crow.)

OGLALA COMMUNITY HIGH SCHOOL 1950–1951 TRACK TEAM. Pictured from left to right are: (front row) William Shangreau, Raymond Hairy Bird, and Francis He Crow; (back row) Theodore Charging Crow, Tim Whetstone, Norman Under Baggage, Carl Charging Crow, and coach Jim Claymore. One person is not listed in the back row. (Photograph courtesy of Francis and Michael He Crow.)

**PINE RIDGE HIGH SCHOOL, 1950-51.** The Pine Ridge High School boys and girls chorus group is pictured here. (Photograph courtesy of Francis and Michael He Crow.)

**HOLY ROSARY GRADE SCHOOL, 1945.** This photo recently came to the author with no further identification. One student is John Siers. (Photograph courtesy of Red Cloud Indian School and Heritage Center.)

114

**1945 HOLY ROSARY BASKETBALL TEAM.** Pictured on the far right in the back row is Coach Bob Clifford. The Brewer Twins and John Siers are in this picture. This photo recently came to the author with only the coach identified and states it is the "Junior Squad." (Photograph courtesy of Red Cloud Indian School and Heritage Center.)

**OGLALA COMMUNITY HIGH SCHOOL FOOTBALL GAME, 1945.** The Oglala Community High School is playing Cheyenne River in the photo. (Photograph courtesy of Francis and Michael He Crow.)

**BILLY MILLS (OGLALA).** Photo taken in 1964. Billy Mills grew up on the Pine Ridge Reservation and later attended Kansas University and served in the U.S. Marines. He surprised the world of track and field when he won the gold medal in the 10,000-meter race in the 1964 Olympics in Tokyo. His parents are Sidney Mills and Grace Allman Garcia. Billy's grandfather was Ben Mills. Today, Billy Mills is a successful businessman, author, and outstanding role model for youth and people of all races. (Photograph courtesy of Billy and Patricia Mills.)

**SUANNE BIG CROW (OGLALA), UNDATED.** SuAnne Big Crow was an outstanding basketball player and an inspiring role model. She holds several South Dakota State basketball records including a record of 67 points scored in one game. She led Pine Ridge High School to the South Dakota State A Basketball Championship in 1989. SuAnne passed away in 1992 at the age of seventeen. She promoted cultural understanding in her life and the SuAnne Big Crow Boys and Girls Center ("Happytown") was established in her memory. (Photograph courtesy of CeCe Big Crow.)

*Opposite:* **MEETING WITH PRESIDENT JOHN F. KENNEDY, C. 1962.** Pictured from left to right are: Jack T. Conway, President Kennedy, Marie C. McGuire, Johnson Holy Rock (Oglala), Richard Schifter, and Fred A. Forbes. Johnson Holy Rock, president of the Oglala Sioux Tribe met with John F. Kennedy in Washington D.C. At this time, President Kennedy announced the first public housing low-rent planning grant to the Oglala Sioux Tribe. The group is pictured in the president's office in the White House. Mr. Conway was deputy administrator, Marie McGuire was the public housing commissioner, Richard Schifter was a Washington D.C. attorney for the tribe, and Fred Forbes was assistant administrator of public affairs. (Photograph courtesy of Oglala Lakota College Archives.)

## Seven

# WAZI BLO OWAKPAMNI
## (Pine Ridge Reservation 1950–2005)

*Today the Pine Ridge Reservation is still rich in its Lakota culture and traditions, despite the fact that it is one of the poorest reservations in the United States The termination and relocation programs begun in the 1950s greatly affected the American Indian people during this era. Some tribes were terminated, no longer recognized by the United States government, and relocation involved acculturation and assimilation into urban areas for training and education.*

*In 1968, the U.S. Indian Civil Rights Act was created, and in 1969, tribal colleges were created. The Oglala Lakota College serves the people with 12 college centers throughout the reservation and one in Rapid City, South Dakota. By 1972, President Nixon had stated that the new era would be known as "Self Determination," and since 1974, tribes have been contracting for services from the federal government, so as to have more power in running their own affairs. In 1978, the Indian Religious Freedom Act and the Indian Child Welfare Act were enacted. In 1988, the Indian Gaming Act was created, and the Oglala Lakota tribe now operates the Prairie Winds Casino. Ranching and farming are still occupations that compliment the land base, although less productive now because of the economy. Tribal sovereignty, cultural preservation, and building a local economy are keys to the future.*

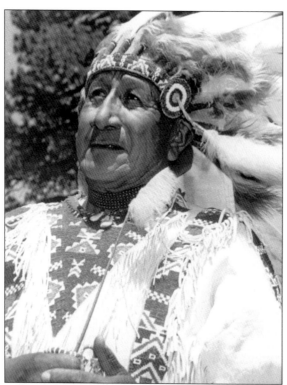

JIM IRON CLOUD (OGLALA), UNDATED. Jim Iron Cloud is shown here in traditional dress. He was president of the Oglala Sioux Tribe from 1956-1958 and was involved in tribal government. (Photograph courtesy of Oglala Lakota College Archives.)

BEN AMERICAN HORSE, UNIDENTIFIED, JESSIE AMERICAN HORSE, ELLEN BLACK ELK, BEN BLACK ELK, AND HOWARD BAD BEAR (OGLALA), C. 1966. This group is traveling by airplane. Howard Bad Bear was identified by Roseline Little Bear's grandfather, and Mr. and Mrs. American Horse were identified by Leona Crazy Thunder. The photographer is unknown. (Photograph courtesy of Oglala Lakota Archives.)

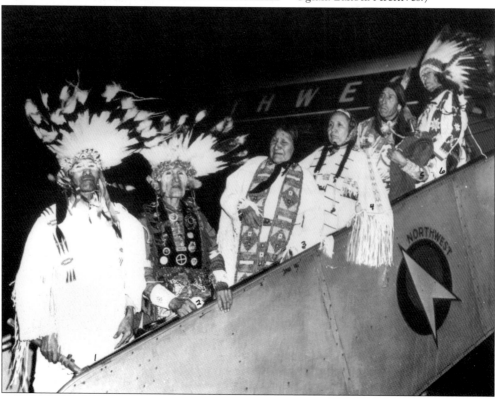

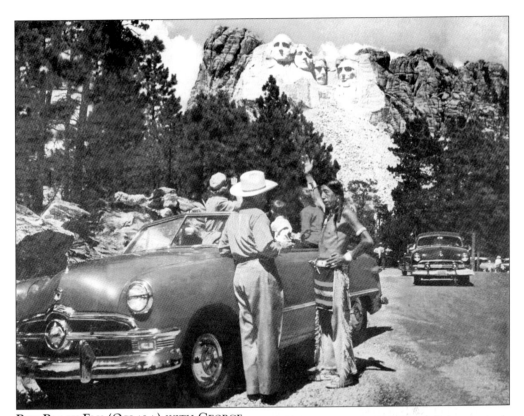

BEN BLACK ELK (OGLALA) WITH GEORGE E. WILSON, MILDRED WILSON, TOM WILSON, AND JIM WILSON, C. 1950. Ben Black Elk poses with Black Hills residents for a front cover photo for the magazine *Better Homes and Gardens'* "Special Travel Issue." The tourists are the Wilson family: George E., his wife Mildred, and sons Tom and Jim. They are in front of Mt. Rushmore as Ben Black Elk describes the monument to them. The magazine published the special travel issue for the tourism industry, and the Black Hills were featured, along with other significant attractions across the United States. The photo was provided by Tom Wilson, who works with the author. (Photograph courtesy of Tom Wilson.)

RICK MCLANE (OGLALA/MINNICOUJOU). This photo was taken in 1968. Rick McLane was in the U.S. Army at this time and later joined the U.S. Marines. (Photograph courtesy of Alvera Wise.)

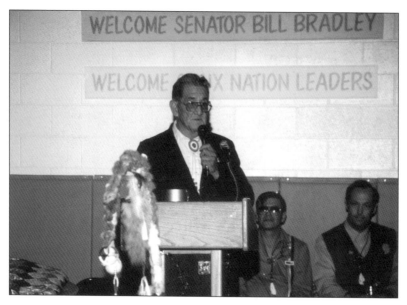

JOHNSON HOLY ROCK (OGLALA), JOHN YELLOW BIRD STEELE (OGLALA), AND SENATOR BILL BRADLEY. This photo was taken by Jerry Matthews in 1972. Senator Bill Bradley has been a long-time supporter of the Lakota people. Johnson Holy Rock was a former tribal president. He is currently the fifth member of the Oglala Lakota tribal council. John Yellow Bird Steele is the current President of the Oglala Lakota Tribe, and is a former president. (Photograph courtesy of Oglala Lakota College Archives and Jerry Matthews.)

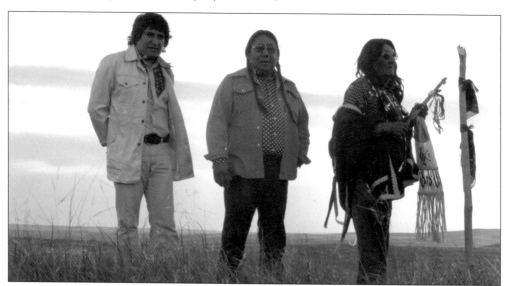

DENNIS SUN RHODES, BIRGIL KILLS STRAIGHT (OGLALA), AND CHIEF FRANK FOOLS CROW (OGLALA), 1977. This photo, taken by Steve Langley, shows a ground breaking ceremony. Dennis Sun Rhodes is an architect, Birgil Kills Straight is from Kyle and has worked for Oglala Lakota College, and Frank Fools Crow was a renowned medicine man from Kyle, South Dakota who was born about 1888. Frank Fools Crow married Fannie Afraid Of Hawk in 1916. Fannie's father was Emil Afraid Of Hawk. Fools Crow married Kate Fools Crow in 1958. Kate was born in 1885. The father of Frank Fools Crow was Eagle Bear Crazy Crow, and his mother was Spoon Hunter. Frank passed away in 1989; he lived almost 100 years. A book was written about Frank entitled *Fools Crow*, by Thomas Mails. (Photograph courtesy of Steve Langley and Oglala Lakota College Archives.)

**WILBUR BETWEEN LODGES (OGLALA), 1976.**
Wilbur Between Lodges married Cheryl Two
Bulls, daughter of Matt and Nellie Two Bulls.
He was vice president of the Oglala Sioux
Tribe from 1990-1992, 5th member from
1992-1994, president from 1994-1996, and
vice president from 1998-2000. (Photograph
courtesy of Oglala Lakota College Archives
and Jerry Matthews.)

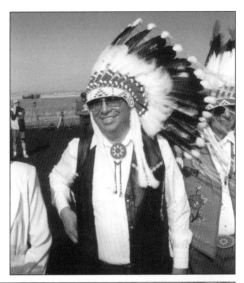

**DONOVIN SPRAGUE (MINNICOUJOU) AND PETE HELPER (MINNICOUJOU), 2002.** The author
is pictured here with his uncle, Pete Helper. Pete is 94 years old and grew up and lived on
Pine Ridge Reservation. He married Lillie Red Shirt (Oglala), and his father was Sam Helper
who was earlier known as Stands By/True. Sam was the son of Chief Hump (II) and his wife
Good Woman. Sam survived the Wounded Knee Massacre and married Mary Thunder Hawk,
another survivor of the massacre. The agency wanted to move them back to Cheyenne River
Agency, where they had come from on their journey to Wounded Knee. Sam Helper wished
to remain at Pine Ridge, and told the agency that if allowed to stay at Pine Ridge he would
help out at the agency. He was given the name Helper at that time. Pete is the grandson of
Chief Hump (II). Pete's brothers and sisters have all lived at Pine Ridge Reservation, and their
spouses, all Oglala, include: Dora Helper (Mrs. Edward Two Bulls), Sadie Helper (Mrs. Wilbur
Blackfeather), Martha Helper (Mrs. Pete Two Bulls Sr.), and Jake Helper (married Evelyn Poor
Thunder). These families have all lived at Pine Ridge and are members of the Oglala Lakota
tribe. Pete has enjoyed great health while living the old Lakota way at his home in the country.
Pete and his daughter Darlene provide valuable information and interviews for historical
research. The author is the great-great grandson of Chief Hump (II) and his wife White Calf.
The father of Hump (II) was Chief Hump (I), also known as High Back Bone (Minnicoujou);
he was the uncle of Chief Crazy Horse on Crazy Horse's mother's side of the family.

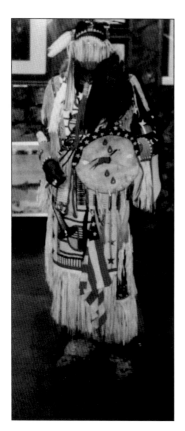

ED YOUNGMAN/FEATHERMAN (OGLALA), C. 2001. Ed is a traditional dancer and has worked at the Little Wound School for 20 years. He is the great-great grandson of Young Man Afraid Of His Horses. He comes from a family of hereditary shirtwearers, and should be recognized himself as a shirtwearer of the Oglala. His regalia incorporates designs of the American flag and he is a veteran. Native Americans have the highest rate of participation in the military of any ethnic group. Fifty percent of Native Americans are U.S. veterans. (Photograph courtesy of Donovin Sprague.)

STANLEY LOOKING ELK (OGLALA), OCTOBER 1977. Stanley Looking Elk was involved in tribal government and served as president of the Oglala Sioux Tribe during 1980-1982. (Photograph courtesy of Oglala Lakota College Archives and Jerry Matthews.)

**EDWARD "EDDIE" TWO BULLS SR. AND EDWARD "TOM" TWO BULLS III (OGLALA), JULY 27, 2004.** Eddie and his son Tom are pictured in front of Eddie's artwork. The Two Bulls family is well-known for their great artistic talent. Edward E. Two Bulls was born at home in February 1938 at Red Shirt Table, South Dakota to Edward Two Bulls

Sr. and Bessie Little Killer. Bessie's mothers name was Provost, and the father of Edward Sr. was Fred Two Bulls. Fred's original name was Jacket. He married Cecilia "Lovie" Big Boy who was born in Kyle, South Dakota in 1943. Their family consists of Andrea Two Bulls, Edward Two Bulls III, Darlene Two Bulls-Custer, Ernest Two Bulls, Patricia Ann Two Bulls Anthony, and Anthony Lewis Two Bulls. Their relative, Jimmy Comes Again was a veteran of the Battle of the Little Bighorn. Jimmy Comes Again and John Sitting Bull were photographed in a 1948 picture of a group of eight of these veterans. Comes Again and Sitting Bull were often around Eddie's home and John Sitting Bull made Eddie a bow with arrows. Eddie said the arrows did not shoot straight and he put the bow away. Several months later he tried it again and the wood had cured and the bow worked perfectly. The two men told him stories about the Battle of the Little Bighorn and drew pictures in the dirt of their location at the battle. Sometimes Eddie's mom came by and laughed at them, erasing their pictures. Jimmy Comes Again and John Sitting Bull were very young at the Battle of the Little Bighorn. Eddie was also present when the photo of the eight men was taken in the Black Hills in 1948. He was then 10 years old. (Photograph courtesy of Donovin Sprague.)

**JOHNSON HOLY ROCK, MELVIN CUMMINGS, CHARLIE UNDERBAGGAGE AND JAKE LITTLE THUNDER, UNDATED.** Johnson Holy Rock was a former president of the Oglala Sioux Tribe and is meeting here with a council. Johnson's parents were Jonas Holy Rock and Polly Bird Necklace. Jonas' father was White Twin, brother of Black Twin, who were twins and renowned warriors and leaders in early Lakota history. (Photograph courtesy of James R. and Candy Cummings.)

**LAURA GALLEGO-BREWER AND FAMILY (OGLALA), APRIL 2003.** Pictured from left to right are: Tom Brewer, "Gabby" Brewer, Elena Dameron, Fred "Budger" Brewer, and Willard Brewer. Laura Gallego-Brewer is gathered here with her children to celebrate her 90th birthday in Rapid City, South Dakota. Laura grew up at Pine Ridge Reservation, and then became a nurse at Winnebago, Nebraska, and now lives in Omaha. Tom lives in Rapid City, "Gabby" and "Budger" live in Pine Ridge, Elena lives in Omaha, and Willard now resides in Denver, Colorado. CeCe Big Crow is a friend of the author and assisted with family information. (Photograph courtesy of CeCe Big Crow.)

**MATT AND NELLIE "BLUE BIRD WOMAN" TWO BULLS (OGLALA).** This photo is undated. Matt and Nellie Two Bulls have made outstanding contributions to Lakota culture and throughout the world with their traditional music, dance, and life. They

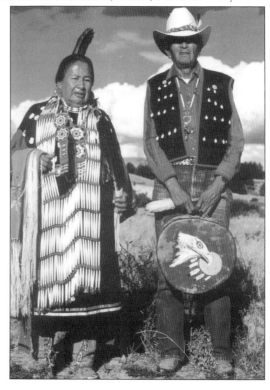

were married when Nellie was 16 and Matt was 20 years old. Matt and Nellie had seven children, and of these three daughters are living. They were married for over 50 years when Matt passed away. Matt was the lead singer for "Sons of the Oglala" and Nellie was the female lead singer. Matt's family name was Two Buffalo Bulls. Nellie "Blue Bird Woman" taught at Red Cloud School for 27 years and also at Oglala Lakota College. Matt also taught at both of these schools. The City of Rapid City proclaimed a day "Matthew and Nellie Two Bulls Day." Nellie White Horse was born to George White Horse and Susan Black Sheep. Nellie was raised by her grandparents Jarould/Jerry White Horse and his wife Bessie White Rabbit. Jerry died in England in a train wreck while working with Buffalo Bill's "Wild West Show." Her grandmother Bessie White Rabbit then married Tom Mills and they had three boys. Nellie is now 77 years old. (Photograph courtesy of Crazy Horse Memorial Foundation.)

SOUTH DAKOTA GOVERNOR MIKE ROUNDS (LEFT), TOM SHORTBULL (OGLALA/SICANGU), JOHN YELLOW BIRD-STEELE (OGLALA), AND NEWTON CUMMINGS. This photo was taken during the Oglala Lakota College graduation at Piya Wiconi near Kyle, South Dakota. Tom Shortbull is a former state legislator, tribal president, and presently president of Oglala Lakota College. His parents are Norman and Elizabeth Prue Larsen. Norman is from Wanblee, South Dakota, and Elizabeth came from Rosebud Reservation. John Yellow Bird-Steele has been active in tribal government, including being president of the Oglala Lakota Tribe. John is standing in the back with no hat. Newton Cummings is on the far right wearing a cowboy hat. Gov. Mike Rounds is the present governor of South Dakota. (Photograph courtesy of Tom Shortbull.)

VANESSA SHORTBULL, MISS SOUTH DAKOTA 2002 (OGLALA/SICANGU). This photo was taken in 2002. Vanessa Shortbull won the title of Miss South Dakota in 2002 and was also Miss Rapid City. She is the second Lakota to win the Miss Rapid City title, along with Elizabeth Whipple. Tatewin Means was the 1996 Miss SD Teen USA and daughter of Russell Means. Vanessa and Tatewin were college students in the author's class and Elizabeth Whipple (daughter of Mr. and Mrs. Vince Whipple, Sr.) was his secretary. Vanessa performs ballet and is presently completing a Master's Degree at the University of South Dakota and is planning to attend law school. She is the daughter of Tom and Darlene Shortbull and she is a direct descendant of Chief Short Bull and Chief Red Cloud. A special person in Vanessa's life is her grandmother Sadie Janis who is 93 years old and lives in Rapid City, South Dakota. (Photograph courtesy of Vanessa Shortbull.)

# Index

Afraid 26
Afraid Of Horse, Frank 88
American Horse 13, 22, 48, 61
American Horse, Ben 118
American Horse, Jessie 118
American Horse, Robert 13
Amiotte, Jerry 91
Bad Bear, Howard 118
Bad Cob 58
Bad Heart Bull, Julius 113
Bad Heart Bull, Norma
(Two Bulls)? 81
Bad Wound 40
Bear Don't Scare 110
Beard, Andrew 109
Bettelyoun, Ethel Marcie 101
Bettelyoun, Ramona
(Randall) 101
Bettelyoun, Sophia
(Wabanassum) 99
Bettelyoun, Waldrin "Wally"
Jerome 101
Belt, Ambrose 95
Between Lodges, Wilbur 121
Big Crow, SuAnne 116
Big Mane 13
Big Road 13
Big Turnip, Sophia
(Runs Against) 79
Bissonette, Frank 111
Bissonette, Jackson 111
Bissonette, Lillie 111
Bissonette, Theresa 111
Black Bear 59
Black Bear, Thomas 109
Black Bear, Willis 109
Black Bird 59
Black Crow 55
Black Elk, Ben 102, 118, 119
Black Elk, Ellen 118
Black Eyes, Nancy 111
Black Horse, Jessie 75
Black Shawl 15
Blacksmith, Melvin 113
Blue Horse 38
Blue Legs, Alice 39
Blue Legs, Kate (Garreau-Poor
Elk-McGras-Hunter-Hall)
99, 100
Boesl, John J. (Zither Dick) 55
Bradley, Senator Bill 120
Brave, Charles 109
Brave Chief 22
Brave, Dora (Shoulders) 79
Brave, Sara 79
Brewer, Fred "Budger" 124
Brewer, Gabby 124
Brewer, Laura (Gallego) 124
Brewer, Tom 124

Brewer twins 115
Brewer, Willard 124
Bridgeman, Mary 110
Broken Rope, Samuel 111
Brown Bull, Lucille
(Two Bulls) 83
Bull Bear 12
Bullman, Mabel
(Long Soldier) 107
Calls Her Name 24
Carlisle Indian School students
1879-1880 110
Carlisle Indian School 1884? 109
Carlisle Indian School students
1887 110
Carlisle Indian School football
team 1917 110
Carlow, Lizzie 111
Charge In The Enemy,
Willie 84
Charging Crow, Carl 113
Charging Crow, Theodore 113
Chase Close To Lodge,
Charles 64
Chase In Winter, Winola
(He Crow) 74, 82
Chipps, Ellis 78
Claymore, Jim 113
Cloud Shield, Henry 88, 92
Cody, William F.
"Buffalo Bill" 22, 74
Colhoff, Ramona
(Two Bulls) 83
Comes Again, Jimmy 33
Comes Out Holy 32
Conquering Bear 59
Conquering Bear, Goldie
(Two Bulls) 81
Conroy, Frank 76
Conroy, Harry 77, 86
Conroy, Julie 76
Conroy, Lila 76
Conroy, Victoria 76
Conroy, Walter 77
Conway, Jack T. 117
Cook, James H. 55
Cottier, George 111
Cottier, Henry 111
Crazy Bear 13
Crazy Horse, Albert
aka Greasing Hand 43, 57
Crazy Thunder, Jeanette
(Randall) 98
Crazy Thunder, Nickolas 98, 101
Creathbaum, Vivian
(Two Bulls) 83
Crow, Russell 113
Cummings, Melvin 123
Cummings, Newton 125

Cuny, Ruth (Yellow Horse) 83
Dameron, Elena 124
Dark Face, Jeanette 101
Day, Lucy 110
Delegation (Oglala) 1899 59
Delegation of
Sioux Indians 13, 31, 61
Deon, Nettie (Hairy Bird) 106
Dion (Deon), Sam 109
Dyer, Margaret (Swallow) 81
Eagle Bear 34
Eagle Chief 22
Eagle Hawk, Agnes 104, 105
Eagle Hawk, Joe 104, 105
Eagle Hawk, Tibbits 85, 105
Ear Of Corn
(Mrs. Lone Wolf) 44
Ecoffey, Rose 106
Fast Horse, Alice Mae
(Hall-Garreau)
97, 98, 100, 100, 101
Fast Horse, "Sybil" Darlene
(McLane) 98, 100, 101, 102
Fast Horse, Levi 90
Fast Horse, Roberta Virginia 101
Fast Horse, Robert Andrew
98, 99, 100, 101
Fast Horse, Vandall William 100
Fast Horse, William 98
Fast Thunder 13, 72
Fast Wolf, Dora (Two Bulls) 83
Fast Wolf, Imogene (Sherman)
aka Kills A Hundred 83
Fast Wolf, Jimmy 83
Fast Wolf, Larry 83
Fast Wolf, Todd 83
Fetterman Site 29
Fire Lightning 13
Fire Thunder, George 31
Fire Thunder,
William "Billy"? 106
Flies, Rosa 111
Flys Above 22
Fools Crow, Chief Frank 120
Forbes, Fred A. 117
Galligo, Laura (Brewer) 124
Galligo, Margaret
(Shangreaux) 106
Garnett, William "Billy" 61
Garnier, Julie (Two Bulls) 83
Garreau, Alice Mae (Hall-Fast
Horse) 97, 98, 100, 101
Garreau, Beatrice (Swallow) 83
Garreau, Kate (Poor Elk-
McGras -Hunter-Hall-
Blue Legs) 99, 100
George, James A. 31
Glade Daisy 110
Gillespie, Jenny 113

Good Boy, Herbert 109
Good Soldier, Cora 96
Good Soldier, Lucy
(Two Bulls) 81, 83
Good Soldier, Richard 96
Good Voice 13
Goodwin, Julia 111
Goulette, Louise 111
Grass 13
Grass, John 13
Greasing Hand aka Albert
Crazy Horse 43, 57
Hail Stones In Her Stomach 35
Hairy Bird, Nettie (Deon) 106
Hairy Bird, Raymond 113
Hall, Alice Mae (Garreau-Fast
Horse) 97, 98, 100, 101, 119
Hall, Clifford James 99
Hall, Kate (Garreau-Poor Elk-
McGras-Hunter-Blue Legs)
99, 100
Hard Heart 59
Has No Horses 17
Hauff, Cordelia Wilma
(Randall) 101
He Crow 38
He Crow, Francis 87, 113, 114
He Crow, Francis? 74
He Crow, Hermis 88, 113
He Crow, Hermis? 74
He Crow, Jackson 74, 82
He Crow, Jeff 94
He Crow, Leonard 91
He Crow, Moses 91
He Crow, Mr. 92
He Crow, Norman 111
He Crow, Robert 89
He Crow, Winola
(Chase In Winter) 74, 82
He Dog 13, 40, 41, 61, 73
Helper, Peter Sr. 121
Herman, Jacob 110
High Crane 86
High Eagle, Joe 30
High Hawk 59
High Hawk 13
High Horse 18
High Pipe 13
Hollow Horn Bear 13
Holy Eagle, James 80
Holy Pipe, Charles 85
Holy Rock, Johnson 117, 120
Holy Rosary School 114, 115
Horn Chips, Charles 78
Horn Chips, Mr. and Mrs. 36
Horn Cloud 69
Horse, Robert 109
Hump 13
Hunter, Kate (Garreau-Poor

Elk-McGras-Hall-
   Blue Legs)      99, 100, 119
Hunter, Victoria (Sherman)   60

Hunts The Enemy aka
   Sword/George Sword  48, 61
Iron Cloud, Jim      118
Iron Tail "Sinte Maza"   49, 74
Iron Whiteman, Mr.?      16
Janis, Emily (Two Bulls)   81
Joy, Carol (Two Bulls)   83
Jumping Bull, Chris      85
Kennedy, President John F.  117
Kicking Bear      31
Kills A Hundred aka Imogene
   Fast Wolf-Sherman   83
Kills Above, John      55
Kills Above, Mrs. John   55
Kills Brave      20
Kills Plenty aka Kate Garreau-
Poor Elk-McGras-Hunter-Hall-
   Blue Legs      99, 100
Kills Ree, Jessie      79
Kills Straight, Birgil   120
Kills The Enemy, Charles   97
Knife, Andrew      66
Knife Chief      22
Lamont, Pete      13
Larrabee/Laravie/Larvie, Helen
   aka Nellie aka Ellen   58
Last Horse      59
Lean Woman
   "We-tamahecha"   54
Left Hand, Andrew      93
Left Hand, Mr. and Mrs.   93
Lewis, F.D.      13
Little, Amos      64, 105
Little, Mr. and Mrs. Amos   105
Little Big Man      36, 61
Little Chief      30
Little Chief, Elmore   111
Little Dog, Fannie   79
Little Horse      42, 63
Little Killer, Bessie
   (Two Bulls)?      81
Little Soldier, Sally   21
Little Thunder, Jake   123
Little Wound
   13, 31, 47, 50, 59, 61
Little Wound, Mrs.
   (Tells Lies)      47
Little Wound's son      47
Lone Bear      47, 59
Lone Bear, Alice      45
Lone Bear, Henry      45
Lone Bear, Samuel      19
Lone Elk      42
Lone Feather      35
Lone Goose, John   102
Lone Hill      110
Loneman School Basketball
   Team 1941-42      85
Loneman School 8th Grade
   1945      113

1946      112
Lone Wolf      44
Lone Wolf, Mrs.
   (Ear Of Corn)      44
Lone Wolf, Buffalo   111
Lone Wolf, Emily   111
Lone Wolf, Nathan   111
Lone Wolf, Oliver & family  107
Long Soldier, Mabel
   (Bullman)      107
Long Wolf      22
Looking Elk, Stanley   113, 122
Mad Bear      13
Manabove, Alex   109
Man Afraid Of His Horses   28
Manderson, S.D.
   Sewing Club      79
Marley, Ethel May      81
Marrowbone, Richard   85
Marshall, Jennie
   (Two Bulls)      81
Marshall, Sarah (Steele)   81
McLane, Rick   119
McLane, Robert Wayne   102
McLane, Sybil "Darlene"
   (Fast Horse)   102
McGras, Kate (Garreau-Poor
   Elk-Hunter-Hall-
   Blue Legs)      99, 100
McGregor, George   113
McGuire, Marie C.   117
Medicine Bull      13
Merrivale Jose      61
Mesteth, Rose      79
Mills, Billy   116
Moller, Tillie (Two Bulls-Poor
   Thunder)      81
Morgan, Commander T.J.   13
Moves Camp, James      78
Nelson, Charles      22
Nelson, James      22
Nelson, John Y.      22
Nelson, Julia      22
Nelson, Mrs.      22
Nelson, Rosa      22
Nelson, Thomas      22
No Flesh, Mabel   111
No Heart      13
No Neck      70
No Neck?      49
No Neck and his wife      70
No Water, Chief      70
No Water, Eugene      85
No Water, Louisa
   (Sword)      65, 85
No Water, Thomas
   46, 65, 69, 80, 85
Oglala, S.D. church group   79
Oglala Community High
   School football game
   1945      116
Oglala Community School
   c. 1940s      112
Oglala Lakota College students

at Fort Robinson      56
Oglala Lakota College and
   BHSU students at
   Red Cloud Agency      53
101 Indian Band      50
One Star, James   109
One To Play With      13
Painted Horse, Chief   51
Pallardy, Leon      61
Pemmican      34
Picket Pin      65
Pine Ridge Agency 1879   71
Pine Ridge High School
   1950-51      114
   1950-51 11th Grade   113
Pine Ridge Indian Council  108
Pine Ridge Treaty Council
   1948      103
Plenty Bear      62
Plenty Crow      63
Plenty Horses
   aka Alice Two Bulls   81, 83
Poor Elk, Kate (Garreau-
   McGras-Hunter-Hall-
   Blue Legs)      99, 100
Poor Thunder, Tillie
   (Moller-Two Bulls)   81
Porcupine Butte      75
Pourieau (Pourier), Bat   13, 51
Pourier, Big Bat      51
Pourier, Geraldine   102
Pourier, Josephine      51
Presbyterian Bible School
   1948      111
Pretty Back, Oscar   111
Pulliam, Mrs.      79
Pulls The Bow      20
Pumpkin Seed, Aloysius   105
Pumpkin Seed, Cora      89
Quick Bear      13
Rain In The Face?      35
Randall, Alice Mae
   (Fast Horse)?   101
Randall, Catherine Lucille   98
Randall, Catherine (Wise)   97
Randall, Cordelia Wilma
   (Hauff)   98, 100, 101, 101
Randall, Jeanette Frances
   (Crazy Thunder)
      98, 99, 100, 101
Randall, John Andrew      93
Randall, Ramona Elsie
   (BetteLyoun)
      98, 99, 100, 101
Red Bow, Maize (Two Bulls)  83
Red Cloud, Agnes      55
Red Cloud, Chief   33, 52, 54
Red Cloud, Jack      52, 59
Red Cloud, James H.      55
Red Cloud, Mrs.      54
Red Cloud, Mrs. Charley   55
Red Cloud, Mrs. James H.   55
Red Kettle, Chester   106
Red Horse, Vina   111

Red Paint, Amos      87
Red Shirt, Charles, Jr.?   81
Red Shirt, Mae      81
Red Shirt, Rosa      79
Red Shirt Table Auxiliary   81
Red Shirt Table
   family gathering      83
Red Top, Rosie      40
Rencontreau (Rencountre),
   Alex      13
Richards, Joe      55
Richards, Louis      13
Richards, Mrs. Joe      55
Rocky Bear      22
Rooks, Dora?   106
Rooks, Rosanna   111
Rouilard, Effie      81
Rounds, Governor Mike   125
Running Eagle, Hoover   113
Running Hawk      73
Runs Against, Delia      79
Runs Against, Sophia
   (Big Turnip)      79
Saint Agnes Church,
   Manderson, S.D.   102
Schifter, Richard   117
Shangrau (Shangreaux),
   Louis      13
Shangreaux, Margaret
   (Galligo)   106
Shangreau, William   113
Sharpfish, Narcisse      85
Sheep Mountain,
   Badlands, S.D.      57
Sheldon, A.E.      55
Sherman, Imogene
   (Fast Wolf)      83
Sherman, Victoria
   (Hunter)      60
Short Bull      68
Shortbull, Thomas   125
Shortbull, Vanessa   125
Shot In The Eye      37, 59
Shot In The Eye, Susie   37
Shoulder, Mary   111
Shoulders, Dora (Brave)   79
Siers, John   114, 115
Singer   110
Six Feathers      62
Six Toes, Joe with wife
   and nephew      56
Slow Bull      41
Slow Bull, Howard   109
Smith, Charlie   109
Smith, Esther (Two Bulls)   83
Smith, R.J.      85
Spence, Karl L.      55
Spence, Mrs. Karl L.      55
Spotted Crow, William  103, 106
Spotted Elk
   (not Si Tanka/Big Foot)   13
Spotted Horse      13
Sprague, Donovin   121
Stabber "Wachapa"      10

127

Standing Bear, Stephen   59
Standing Soldier, Andrew
  (painting)   95
Stands First   11
Star Comes Out   46
Steele, John Yellow Bird
  120, 125
Steele, Mary Rose?   81
Steele, Sarah (Marshall)   81
Stinking Bear   31
Straight Head   13
Sun Rhodes, Dennis   120
Swallow, Beatrice (Garreau)   83
Swallow, John, Sr.   81
Swallow, Johnny   81
Swallow, Lizzie (Two Bulls)   81
Swallow, Margaret (Dyer)   81
Swift Bird, Joe   96
Sword, Archie   90
Sword, (George)
  aka Hunts The Enemy aka
  Long Knife   13, 48, 61
Sword, Louisa
  (No Water)   65, 85
Sword, Major George   13
Tall Crane, Chief   43
Tall, Mary   79
Tells Lies
  (Mrs. Little Wound)   47
Ten Fingers, Florence
  (Two Bulls)?   81
Three Bears   61
Three Stars, Clarence   13
Thunder Bear   31
Thunder Hawk, Martin   61, 111
Tobacco   9
Turning Hawk   13
Twiss, Frank   110
Two Bulls, Alice

  aka Plenty Horses   81, 83
Two Bulls, Bessie
  (Little Killer)?   81
Two Bulls, Carol (Joy)   83
Two Bulls, Christina   81
Two Bulls, Delphine
  (Yellow Horse)   83
Two Bulls, Dora (Fast Wolf)   83
Two Bulls, Eddie "Junior"
  59, 83, 123
Two Bulls, Eddie, Sr. II
  59, 83, 123
Two Bulls, Edward III
  "Tom"   123
Two Bulls, Elizabeth   81
Two Bulls, Emily (Janis)   81
Two Bulls, Esther (Smith)   83
Two Bulls, Florence
  (Ten Fingers)?   81
Two Bulls, Frank, Sr.   83
Two Bulls, Fred   32
Two Bulls, Geraldine   83
Two Bulls, Goldie
  (Conquering Bear)   81
Two Bulls, Jennie
  (Marshall)   81
Two Bulls, Julie (Garnier)   83
Two Bulls, Laverne   83
Two Bulls, Lawrence Wayne   83
Two Bulls, Lizzie (Swallow)   81
Two Bulls, Lucille
  (BrownBull)   83
Two Bulls, Lucy
  (Good Soldier)   81, 83
Two Bulls, Maize (Red Bow)   83
Two Bulls, Matt   124
Two Bulls, Moses   111
Two Bulls, Mrs. Fred   60
Two Bulls, Nellie   124

Two Bulls, Norma
  (Bad Heart Bull)?   81
Two Bulls, Norman   83
Two Bulls, Orville   83
Two Bulls, Robert
  "Rev. Bob"   83
Two Bulls, Ramona
  (Colhoff)   83
Two Bulls, Sam   83
Two Bulls, Tillie
  (Moller-Poor Thunder)   81
Two Bulls, Vivian
  (Creathbaum)   83
Two Elk   23
Two Two   18
Two Strike   13
Underbaggage, Charlie   123
Underbaggage, Norman   113
Wabanassum, Sophia
  (Betteljoun)   99
Walker, Rev. Luke   13
Weasel Bear and family   68
Wells, Phillip F.   31
Whetstone, Tim   113
White, Phillips   109
White Bear Claws, James   94
White Bird   13
White Bull, Richard   17
White Clay, Nebraska
  WWII 1945   90
White Ghost   13
White Horse, Eugene   85
White Man Bear   39
White Wolf, Willis   111
Williams, Mrs.   102
Wilson, Barry   101
Wilson, George E.   119
Wilson, Jim   119
Wilson, Mildred   119

Wilson, Tom   119
Wilson, Odgen Francis   101
Wise, Alvera Franklin   101
Wise, Catherine (Randall)   97
Wize   13
Wolf Soldier, Josephine   111
Wolf Soldier, Lizzie   111
Woman Dress   28
Wooden, Mrs. Chester   102
Wooden, Roy   102
Woptuha (Horn Chips)   36
Wounded Horse, Eugene   85
"Wounded Knee" Church   67
Wounded Knee Trading
  Post 1948   104
Yellow Bear   61
Yellow Boy   64
Yellow Bull   35
Yellow Bull, Fannie   102
Yellow Bull, Mrs.   79
Yellow Horse, Delbert   83
Yellow Horse, Delphine
  (Two Bulls)   83
Yellow Horse, Ruth (Cuny)   83
Yellow Horse, Wilbert, Jr.
  "Sonny Boy"   83
Yellow Horse, Verdell   83
Young Chief   22
Young Man Afraid Of His
  Horses   12, 13, 28, 61
Young Man Afraid Of His
  Horses, Ed-Youngman   122
Youngman, Ed   122
Zephier, Dave   13

# Bibliography

Bad Heart Bull, Amos. A Pictographic History of the Oglala Sioux.
Bull Bear winter count mid-1700s–early 1900s (unpublished).
       Courtesy of Bull Bear family.
Carlisle Indian School Records, Carlisle, Pennsylvania.
Hampton Institute School Records, Hampton, Virginia.
Horn Chips winter count 1795-1914 (unpublished). Courtesy of Chipps/Chips family.
Lewis and Clark Journals.
Little Bighorn National Monument Archive Records.
Powers, William K. A Winter Count Of The Lakota. Lakota Books, Kendall, NJ.
       (Winter Count collected from John Colhoff (White Man Stands In Sight)
       in 1949.
Price, Catherine. The Oglala People 1841-1879. University of Nebraska Press: Lincoln
       and London. 1996.
Sprague, Donovin. Cheyenne River Sioux. Arcadia Publishing, Chicago, IL. 2003.
Sprague, Donovin. Standing Rock Sioux. Arcadia Publishing, Chicago, IL. 2004.
Sprague, Donovin. Rosebud Sioux Tribe. Arcadia Publishing, Chicago, IL. 2005.